Far from Main Street

Three Photographers in

Depression-Era New Mexico

Russell Lee

John Collier, Jr.

Jack Delano

Essays by

J. B. Colson

Malcolm Collier

Jay Rabinowitz

Steve Yates

Museum of New Mexico ⊩

Santa Fe

Library of Congress cataloging information available.
ISBN 0–89013–259–3

Museum of New Mexico Press
Post Office Box 2087
Santa Fe, New Mexico 87504

Manufactured in the United States of America
10 9 8 7 6 5 4 3 2 1

All photographs are selected from the Pinewood Collection of New Mexico FSA Photographs, in the Museum of Fine Arts, Santa Fe, New Mexico. This special collection was funded, in part, with a generous contribution from Celeste and Armand Bartos. Primary support was generously provided by the Pinewood Foundation, with additional support from the National Endowment for the Arts, the Marshall L. and Perrine D. McCune Charitable Foundation, and Barbara Erdman. The museum wishes to extend special thanks to U.S. Senator Jeff Bingaman. Prints were made from original negatives generously loaned by the Library of Congress Prints and Photographs Division.

Designed, photographically edited, and typeset in Minion with Universe Condensed by Eleanor Caponigro.
Printed by Meridian Printing from duotone negatives by Robert Hennessey.

FSA, FARM SECURITY ADMINISTRATION (1937–1942)

This federal agency was established in 1935 as the Resettlement Administration. The name was changed to Farm Security Administration in 1937, when the agency was transferred to the United States Department of Agriculture. The historical section of the FSA was directed by Roy Stryker. This government bureau hired photographers to document America during the Great Depression. Their work subsequently influenced documentary style in twentieth-century photography.

OWI, OFFICE OF WAR INFORMATION (1942–1945)

This federal agency was established within the Office for Emergency Management. It consolidated many other agencies, including the historical section of the Farm Security Administration.

WPA, WORKS PROGRESS ADMINISTRATION (1935–1939)
later renamed Work Projects Administration

This independent federal agency was established in accordance with the Emergency Relief Appropriation Act of 1935. It was one of many domestic reform programs initiated by President Franklin D. Roosevelt, and it included funding for arts projects.

Contents

1. **Farm children buying candy at the general store. Pie Town, June 1940**
Photograph by Russell Lee

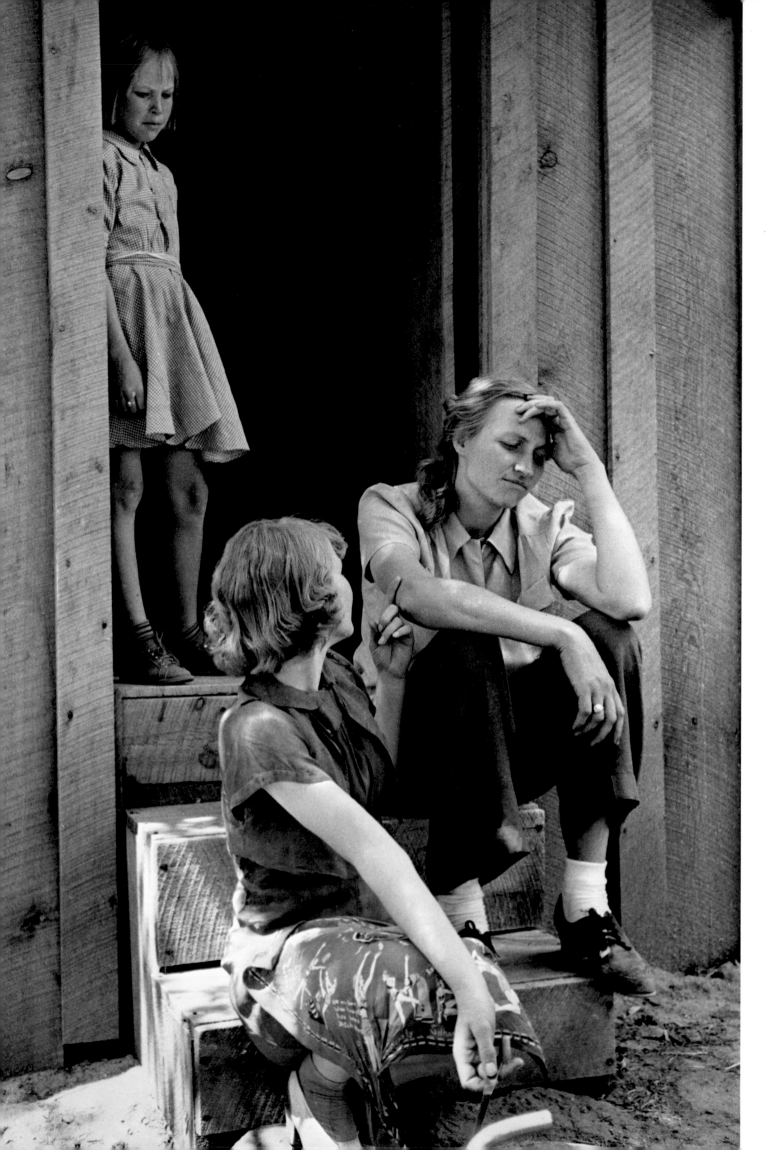

The Art of the Human Document: Russell Lee in New Mexico

J. B. Colson

Russell Lee began his rich and varied photographic career working for the FSA. Traveling the country on assignment for administrator Roy Stryker, Lee produced for this federal government agency many of its most esteemed human documents, some of the best of them while he was in New Mexico. In direct, honest records of his encounters, Lee captured the spirit of his subjects and transcended the immediate scenes before his camera. The photographer was as straightforward and unpretentious as his pictures, and is as worthy of careful consideration.

Lee's education and temperament had prepared him well for photographing the struggles of everyday life during the Great Depression. From Culver Military Academy in Indiana, where he had been an outstanding scholar and student leader for four years, he went to Lehigh University in Bethlehem, Pennsylvania, and graduated with a degree in chemical engineering. His first job was with the Certainteed Products Company in Illinois; he later became the manager of their roofing company in Kansas. In 1927 Lee married the promising artist Doris Emrick. Two years later he left the manufacturing business in order to become a painter.[1]

The Lees spent their summers at the artists' colony in Woodstock, New York, where they participated in intense discussions about the pervasive social problems caused by the Depression. They saw its terrible effects everywhere on the streets during their winters in New York City, and Lee's early photographs centered on the human hardships around him.

Using his background in chemistry and engineering, he soon became a master photographic technician. By 1935 he had decided photography was the medium best suited to his vision. The following year he joined the historic photographic project under the auspices of the FSA.

In the summer of 1936 Stryker hired Russell to replace Carl Mydans, who had left the agency to become one of the first staff photographers of the new *Life* magazine. Lee corresponded regularly with Stryker, whose letters from Washington, D.C., explained the needs of the central photographic file, noting potential subjects and places to travel. On April 7, 1939, Stryker wrote: *When you get into the New Mexico area, we are going to have a lot of most interesting work for you. I know you are going to get quite excited about that part of the country, and will want to stay there for a long time.*[2]

Almost two weeks later Lee responded from San Augustine, Texas, where he was finishing a documentary study of the town. After mentioning plans to photograph many subjects, including the oil fields in Kilgore, Texas, and several sites in Oklahoma, he queried Stryker: *If you want me to cover all the things you have mentioned and get out to New Mexico about the middle of May I shall have to move rather rapidly and touch the high spots. . . . Let me know by* telegram *at Marshall what you would like me to do* [April 19, 1939].

It wasn't until early fall of 1939 that Lee finally began work in New Mexico. Stryker's ambitious program, in which Lee was to travel to many parts of the region and work on several themes, remained the same. The photographer planned to *take some pictures of "Bean Day" at Wagon Mound N. Mexico on Labor Day and then will start on the story of the upper Rio Grande going as far north as the Colorado State Line. Taos will be my mail address during this period. After that will go to Roswell and Carlsbad* [September 2, 1939].

Public events, which brought many people together, offered unlimited opportunities for spontaneity without the need for time-consuming arrangements, calculated poses, planned portraits, or other formalities. In these circumstances Lee could work instinctively with the camera, moving quickly and remaining almost unnoticed by his subjects. He captured the natural flow of action and intimate slices of life, which became the hallmarks of his finest pictures. The town of Wagon Mound offered such an opportunity in its annual Bean Day rodeo. By shooting up at spectators from inside the rodeo ring, Lee revealed a cross section of local people (fig. 3). The large number *21* on the back of the contestant on the right helps ground the composition and explain what is happening.

In the photographer's second letter from Taos, he further described these formative experiences in New Mexico. He confronted some of his greatest challenges in the villages of the northern part of the state, where aspects of Spanish colonial culture from the seventeenth century endured:

Was up in Red River N.M. for a few days but had a hell of a time because of rain and cloudy weather. However I managed to get a few good shots of the countryside around Questa and also of a weaving project around Costilla which is reviving the Spanish-Americans' interest in some of their native arts. . . . The people are really grand around

Russell Lee, 1983
Photograph by Ave Bonar

2. **On the front steps. Pie Town, June 1940**

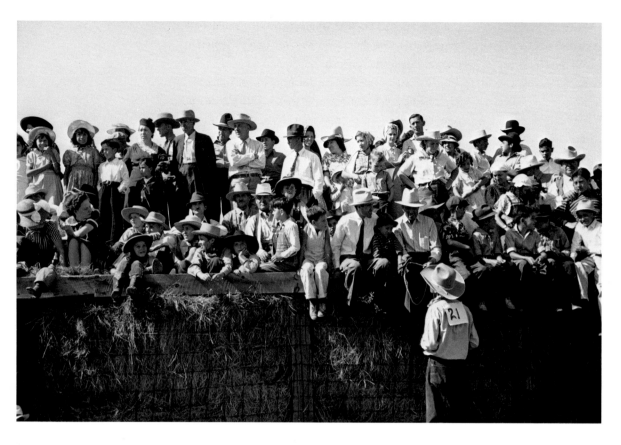

3. **Spectators at the Bean Day rodeo. Wagon Mound, September 1939**

here, but I sure wish that I had a knowledge of Spanish. [about September 1939]

However, Lee engaged people with a natural ease through his unrehearsed use of the camera and his unpretentious manner, which had developed through a series of difficult family situations. Lee was five years old when his father, who had never been accepted by Lee's mother's powerful family, left. Lee's mother was tragically killed in his presence five years later, and he lived with a series of relatives and guardians until his late teens. Responding without rebellion to the ongoing instability of his life, Lee became an achiever.

Stryker sent further assignments to the photographer in Roswell. The government needed some upbeat pictures – ideally, documentation of a boom town – to help balance the record. Wrote the administrator:

We are certainly looking forward to seeing the pictures which you are getting in the upper Rio Grande Valley and in and around Taos. Don't forget a good ranch to go along with some of the more impoverished and small subsistence ranches . . . don't forget that the burro is an important part of that agriculture. We could stand quite a few shots of the little animal, taken in various poses and in various types of work in which he helps; a few pictures of the adobe churches; (Russell, this is very important) if you hear of any boom town of any sort in your vicinity, please make a rush for it, and do a full set of pictures. The town being born – we have pictures of a town dead and dying, but to date we have nothing on the boom side; it is just likely that an oil boom might take place with you being in the near vicinity. [September 16, 1939]

On top of these demands there remained pressing work elsewhere, so Lee left New Mexico late in 1939, returning the following year. However, his constant travel helped build photographic themes over time.

Fundamental to Stryker's approach to producing photography for the FSA file was a knowledge of people and places. He himself lectured about economics and other background topics, but he counted on photographers to do their own research into matters such as geography, industry, and history. He instructed Lee to form a comprehensive plan for New Mexico:

I think it might be a good idea for you to stop a couple of days when you get into N.M., find a good spot, sit down, and do a little thinking about this whole area in which you are going to work. Then, work out a general outline for yourself. . . . When you have finished with your outline, I wonder if you would make a copy for me? I'll go to work on it, and add anything that may come to my mind. [March 19, 1940]

Lee responded on March 26 from San Angelo, Texas, that he expected to leave the next day for Hobbs, New Mexico, a boom oil town that was *just emerging . . . to a stable community.* Project photographers were on the alert for signboards of various kinds, as they reflected the social values of the areas in which they were found. In Hobbs Lee came upon scenes depicting the town life in microcosm, which he captured in images such as that of four signs planted in barren soil that grew little else (fig. 4). One sign promoted oil leases and royalties, two others pointed to nearby churches, and the largest showed a ghoulish face from the Bela Lugosi

film *White Zombie*. Lee's amusing garden of signs remains one of his most telling documents of life.

After Hobbs he stopped in Carlsbad, New Mexico, and then in El Paso, Texas. By this time Stryker had clarified his guiding strategy for making photographs in the field: *Get well in your mind the ideas of general photography, the resources, the agriculture, the population concentration, the outstanding problem areas, and other basic things. Incidentally, I am working on the same thing; after we have done this, I think the type of pictures we'll do will grow out of it pretty logically* [March 29, 1940].

Encouraged, the photographer moved on to Albuquerque, the largest, most centrally located city in the state, in order to concentrate on an approach. He spoke to experts and studied books, maps, and encyclopedias. General readings of related material, rather than directed library research, were part of the groundwork. Unable to find some key publications, including John Steinbeck's *Grapes of Wrath*, Lee sent money back to the capitol for a copy of the novel. The photographer was impressed by its pathos.

The most important preparation for shooting in the field came from conversations with people he encountered in his travels. Government agents in the region provided information and contacts with local officials, whose sense of community aided in the photographic plans. Lee's ability to strike up a friendly conversation, receive information, and generate cooperation was fundamental to his art of the human document.

After leaving Albuquerque, the photographer passed through the small towns of Socorro and Datil on his way to Phoenix, Arizona. During the trip, the unpredictable climate of New Mexico included *windstorms, rain, dust storms, sleet, driving snow and finally tropical heat* [April 20, 1940]. After leaving Datil, Lee made one of the most important discoveries of his career:

Then we crossed the continental divide and on to Pie Town which is a settlement of migrants from Texas and Oklahoma – dry land farmers raising Pinto Beans and corn. Talked with the store owner there and I believe it should be one community we must cover. He called it the "last frontier" with people on farms ranging from 30 to 200 acres – some living in cabins with dirt floors – others better off, but all seemingly united in an effort to make their community really function. [April 20, 1940]

The *we* in the letter referred to himself and Jean Smith Lee, his second wife, a journalist whom he had met on assignment in New Orleans, and who was now traveling with him. Jean actively took part in Russell's fieldwork, making notes and facilitating social interaction. She also firmly supported the goals of the FSA. Though the assignments were rigorous and not always comfortable, she enjoyed life in the field with him.

They became an effective team, discovering and documenting the most human dimensions and challenges of everyday life in America.

In his letter reporting the discovery of Pie Town, the photographer also suggested a six-month period for the shooting of a five-state region. New Mexico, where he planned to spend two months, was at the top of the list. Although the proposal was agreed upon, weather and other demands complicated the realization of the plan. Always looking for likely places to document communities in a comprehensive way, Stryker was encouraging but cautious about the migrant settlement: *Pie Town sounds most interesting. By all means put it on your agenda. If, after you have sampled it, it still seems as good a story as you indicate, then we should encourage someone to write it up, and offer them the pictures to go with it* [April 22, 1940].

Exposing the work of the FSA photographers to large audiences was a central concern for Stryker. In March 1940, *Travel* magazine had used seventeen of Lee's photographs in a story on San Augustine, Texas.[3]

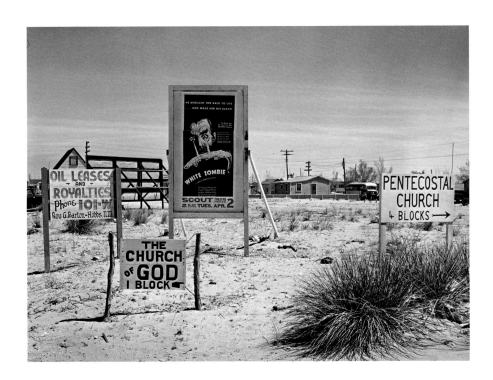

In suggesting how to treat a possible story about Pie Town, Stryker called for an upbeat theme to be developed out of what the photographer sensed from the people there:

The photographs, as far as possible, will have to indicate something of what you suggest in your letter, namely: an attempt to integrate their lives on this type of land in such a way as to stay off the highways and the relief rolls. I suppose the storekeeper was right – a "last frontier." I suspect you had better look pretty carefully under this phrase. Sometimes we get fooled by these "last frontiers." [April 22, 1940]

4. **Signs in a boom oil town. Hobbs, March 1940**

The Lees arrived in Pie Town on the morning of May 30. On the way they stopped to relax with some fishing, one of their favorite recreations, and they visited two other towns: Mogollon, a small mining community, and Reserve, *a town over a 100 miles from a railroad and looking every bit like you might expect it* [May 30, 1940]. The photographer sensed great potential, with historical dimensions, in the life of Mogollon:

Mogollon is by far the best of any mining town we've seen so far and from all accounts it should be really something on pay-day. The town looks very much like the shots I've seen of the real old timers (this is very old, too, having been founded in 1889 and producing ever since). I met the storekeeper and saloon owner and they seemed very cooperative about my statement. I might get back for a real picture story of the town. They said that pay-day was by far the best time to be there – there were fights, drunks in the gutters and everything else you might associate with a mining town. [May 30, 1940]

(Years later, Lee produced a book on other American mining communities.)[4]

He had expected to remain in Pie Town for five days and then return to Mogollon, but the full story of life in Pie Town was unfolding. By Sunday, June 9, he still was photographing there: *Everything's going fine . . . most of the work I've done so far has been in the country – there are a few more shots needed in the town here which I'll get next weekend. Haven't had a bath – outside of a sponge bath – for ten days – so I'm sure going to welcome a shower* [June 9, 1940].

Then, after driving 120 miles to Mogollon, he

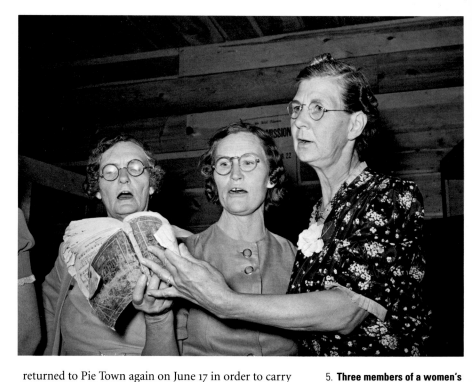

5. **Three members of a women's quintet at an all-day community sing. Pie Town, June 1940**

returned to Pie Town again on June 17 in order to carry out shooting plans directly connected to celebrations: *Next Sunday at Pietown* [sic] *they are having a big community sing – with food and drink as well – it lasts all day so I'm going to be sure to be here for that. Have also discovered that they are cutting in these here mountains by means of the broad-axe so I'll get that when I return. Also there will probably be a big square dance a week from Tuesday here* [June 9, 1940].

Lee's pictures of Pie Town include some of the finest examples of the art of the human document. The work he produced there constituted a high point in his career, and it imparted the essence of the pioneer spirit with a

6. **Serving dinner on the grounds of the community sing. Pie Town, June 1940**

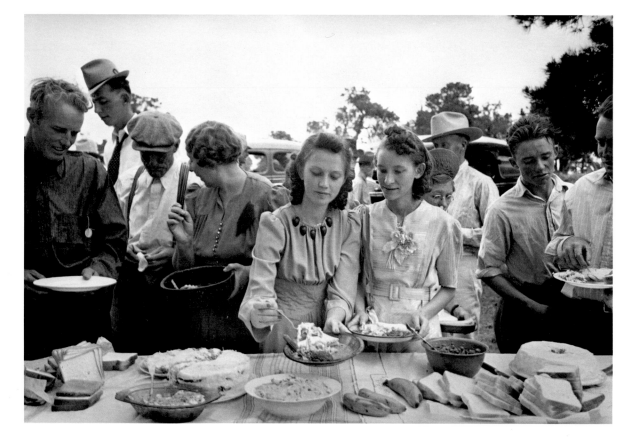

genuine poignancy. His report to Stryker conveyed the depth of his enthusiasm and effort: *Have sent in 21 dozen cut film – and 6 rolls of Contax – you should receive them Monday. The community sing was really grand and the square dance had one of those fast rhythms with a great deal of abandon. I hope my pix show it. Also got the pix of use of the broad-axe in hewing ties* [June 20, 1940].

Lee used several cameras and film formats. Cut film (3¼-by-4¼-inch sheet film) was used in a Linhof Technica camera with a tripod for careful composition – such as landscape and architectural subjects – as well as in an Anniversary Speed Graphic for many of the hand-held flash pictures of dances and other interior events. Two 35mm Contax rangefinder cameras – one with a normal focal length lens and the other with a slightly wide-angle lens – were used for shooting sequences and impromptu subjects. The lenses and film available at that time were slower in speed than their modern-day counterparts, so capturing the essence of events was difficult. Lee's technical facility and resourcefulness helped him transcend such limits. Because of the risk associated with numerous technical uncertainties, he often processed some of his film in hotel bathrooms so he could immediately check the results. The remainder of the processing and all of the printing was done at the government laboratory in Washington.

Beyond technical skills, Lee's mastery lay in documenting an event without disrupting it, thus enabling viewers to participate in it as he had. He uncovered the essential character of a life circumstance by sensing its center and then making the critical exposure with unequivocal timing. Taking pictures of human events is a kind of performance art. Lee's proficiency was like that of a great dancer: his intuition had been developed through rigorous training, and he had a keen awareness of unfolding events. He moved with grace in response to action, synchronizing his photography with the movement of others. Thus, he produced works of art at Pie Town such as *Serving dinner on the grounds of the community sing* (fig. 6), which centers on two young women loading their plates from an outdoor buffet. In this composition the photographer framed his central subjects with others equally intent on the food. The dense grouping of hands and faces offers a complex but integrated vision of a basic human experience – the communal meal. Here, art and life have become one.

At their annual fair in September 1940, the people of Pie Town were treated to a display of Lee's photographs taken there earlier in the year. They were grateful to see the photographer's results: *The pix you sent out are certainly appreciated by the community. I don't believe that you could ever get a more enthusiastic*

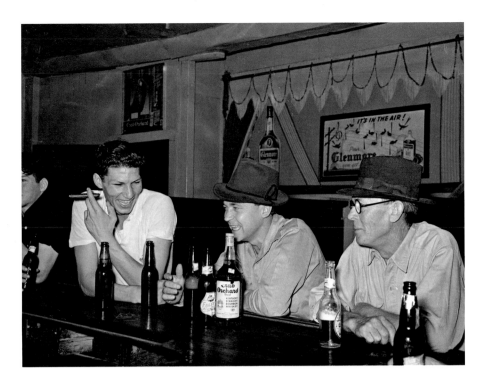

crowd for an exhibit. I tacked them on the walls for everybody to see. The Farm Bureau is going to keep them intact so they may have a good historical record of what Pie Town looked like in 1940* [September 27, 1940].

An increasing focus on the war in Europe seemed to dash any hope for the publication of Russell's photography of Pie Town or of Jean's story based on their experience. National defense was on the minds of citizens everywhere, including New Mexico. Lee reported at one point that even he *was mistaken for a German spy at*

7. **Barroom on payday in a gold-mining town. Mogollon, June 1940**

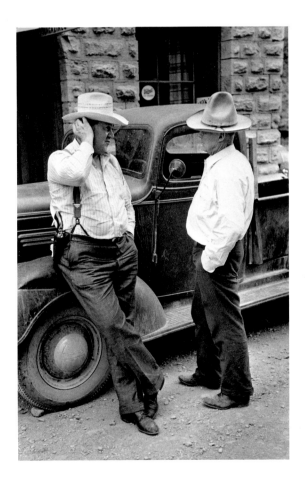

8. **Deputy sheriff and constable. Mogollon, June 1940**

Mogollon but available credentials were apparently satisfactory. However, the deputy sheriff there reported it to Glenwood and Silver City [June 14, 1940]. A few days later, there was more for the story: *Just had another repercussion on the Mogollon incident. The storekeeper at Pie Town said that a tobacco salesman who had been in Mogollon said the F.B.I. was looking for me – that they had caught a spy who had been taking pix of the mines and streets of Mogollon and wanted to question me* [June 20, 1940].

Lee planned to shoot a cross section of life in Mogollon, as he had in Pie Town. The bartender's view of three men having drinks (fig. 7) and the image of a sheriff's spontaneous gesture (fig. 8) offer telling moments of everyday life such as few artists working in any medium have been able to capture.

Lee revealed the underlying character of people, places, and things – and what made them unique. The image of a gold miner wearing a hard hat with miner's lamp and dangling a cigarette from the corner of his mouth (fig. 9) is as incisive as the closeup of a telephone, the internal lifeline of the mines (fig. 10). *Backyard of a house, with steps leading up a hill to the privy* (fig. 11) is classically composed, yet it reveals a reality of life touched with a wry mixture of wit and compassion.

Of all Lee's images, the Pie Town photographs best demonstrate his philosophy and concerns. Forty-six of the pictures, accompanied by Russell and Jean's text and captions, appeared in *U. S. Camera* in October 1941.[5] This essay emphasized the critical role of documentary photography in a free society:

We Americans seem to understand that in our democratic society, people in a far part of the country have a right to know and a need to understand how the other 130,000,000 live and act, so that we can all get along together. . . . The idea is to substitute understanding for machine guns and a Gestapo as a means of keeping the country working together, unified, cooperative. . . . The idea is even a lot more than that . . . pictures which may endure to help the people of tomorrow understand the people of today, so they can carry on more intelligently.[6]

Pie Town was a metaphor for the aspirations of pioneers throughout American history, and the camera a consummate modern tool for the artist: *In Pie Town we could apply a twentieth century camera to a situation more nearly typical of the eighteenth century. We could picture the frontier which has unalterably molded the American character and make frontier life vivid and understandable.*[7]

Lee found the gritty realities of pursuing the American dream being played out in front of his camera. The hardworking settlers, largely from Texas and Oklahoma, were as persistent and tireless as the pho-

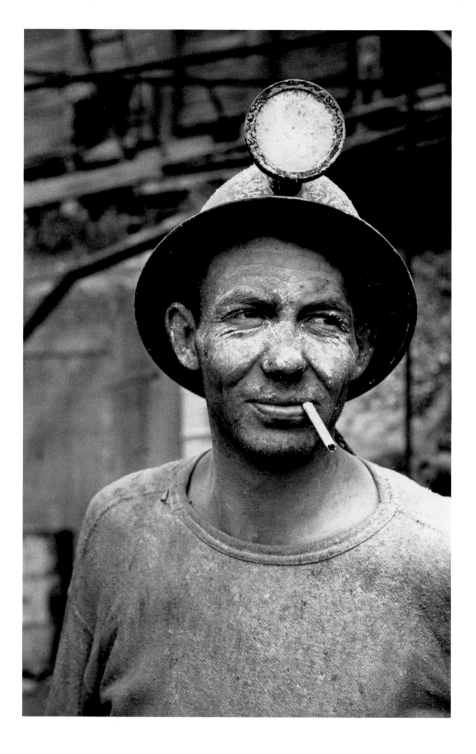

tographer. He understood their enduring hardships, the meaning of their everyday interactions, and their innate sense of community. Lee used photography to help transform commonplace gestures into the motifs of a thoroughly humanistic art.

In the adversity of the 1930s, people often went unrewarded for upholding the standard virtues. However, Pie Town offered evidence that America could still be the land of opportunity, that individual and community virtues were rewarded in their own way.

The art of Lee's New Mexico is not that of beautiful pictures. It is the poetic art of the human document, which reveals a profound understanding of human existence, of people and their unique qualities as they come into contact with the intangible forces that shape their lives. The charge of the FSA was to empower its photo-

9. **Gold miner at the end of a day's work. Mogollon, June 1940**

10. **Telephone used for communication between various points in the gold mine, mill, and office. Mogollon, June 1940**

11. **Backyard of a house, with steps leading up a hill to the privy. Mogollon, June 1940**

12. **Farmers at store. Pie Town, June 1940**

graphers to show how people in diverse circumstances lived. Through the unparalleled achievement and contribution of Russell Lee, viewers can learn and understand more than the plain visual facts recorded by his camera. These photographs magnify experience with the inspired vision that is the province of great works of art.

NOTES

1. An outline of Lee's life is given Colin Naylor, ed., *Contemporary Photographers,* 2d ed. (Chicago: Saint James Press, 1988), 588–90; his life is more fully discussed in F. Jack Hurley, *Russell Lee: Photographer* (Dobbs Ferry, New York: Morgan and Morgan, 1978), 9–35. A listing of Lee's accomplishments at Culver is given in the *Culver Roll Call* (1921), 81.

2. All quotations from correspondence in this essay are from the Roy Stryker Archive in Louisville, Kentucky. The date of the letter accompanies each quotation.

3. Mark Adams, "Our Town in East Texas," *Travel* 24, no. 5 (March 1940), 5–10, 43–44.

4. Joel T. Boone, ed., *A Medical Survey of the Bituminous Coal Industry* (Washington, D.C.: Department of the Interior, 1947). Lee worked on this project from the summer of 1946 until February 1947.

5. Russell Lee, "Life on the American Frontier – 1941 Version," *U.S. Camera* 4, no. 10, (October 1941), 39-54, 88–89, 106-7.

6. Ibid., 40–41.

7. Ibid., 41.

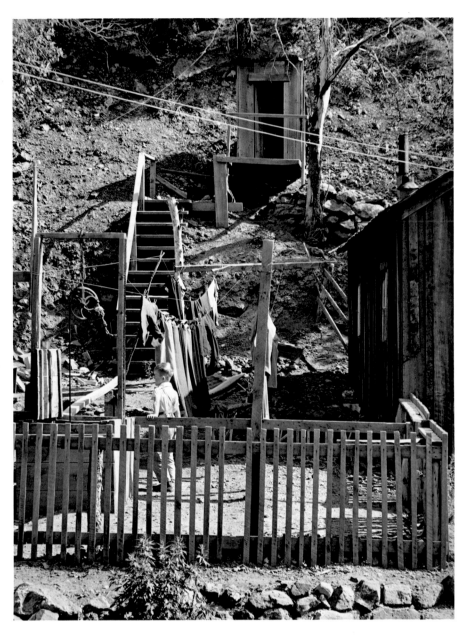

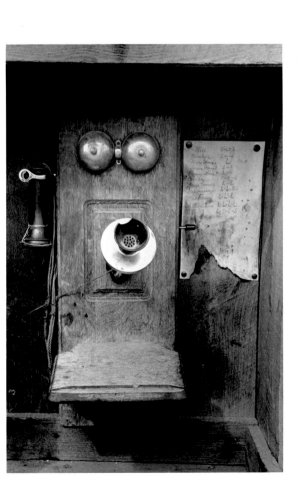

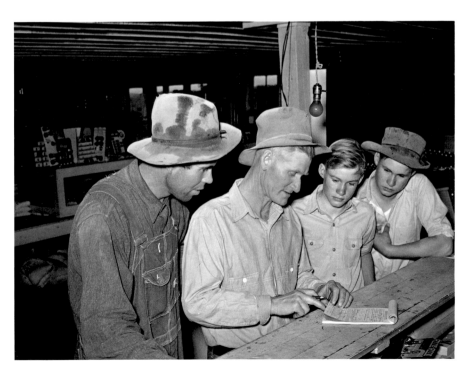

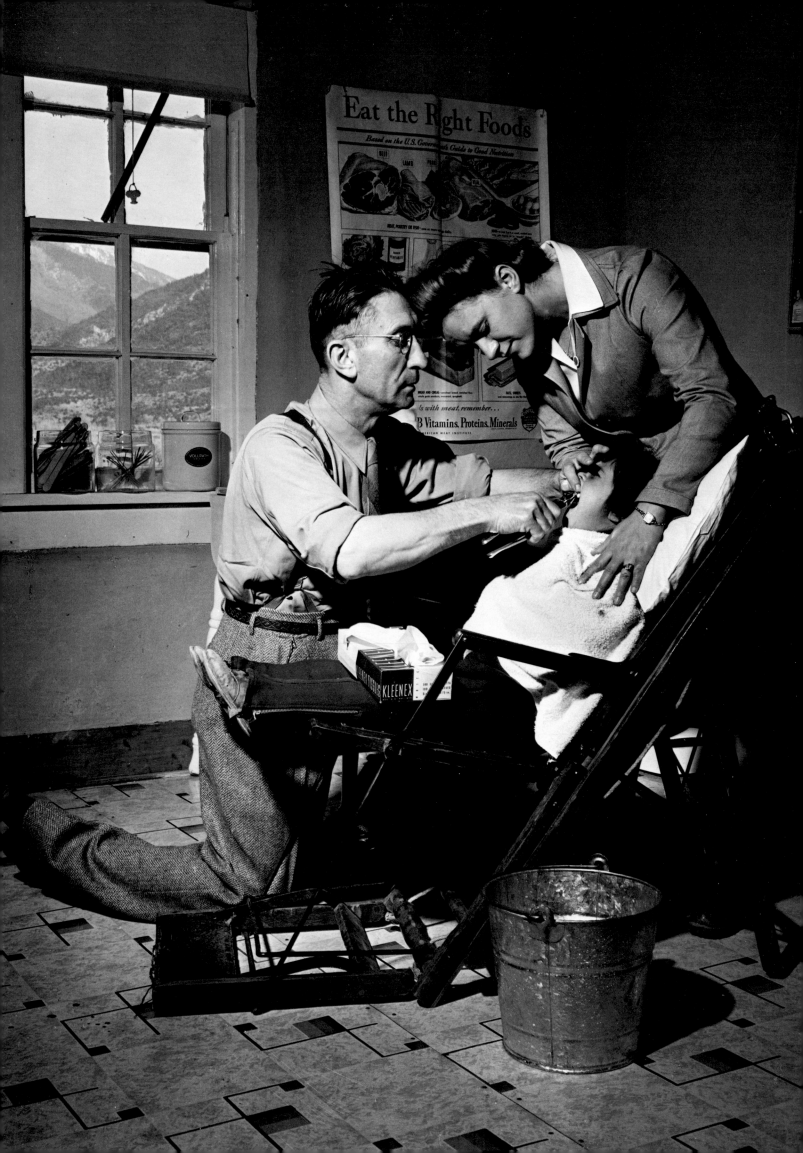

John Collier, Jr. :
Cultural Diversity and the Camera

Malcolm Collier

My father's photographs of New Mexico for the FSA reflect a small part of his work but are expressive of the consistent themes and concerns of his career as photographer, social scientist, artist, and educator. For John, as he was known within the family, photography was primarily a tool, a means to other ends, not an end in itself. It was the vehicle that allowed him to transcend his own considerable limitations, providing him with the capacity to compensate for ever-increasing disabilities. It was also a tool to help others cross boundaries of culture and experience, to achieve new vision and understanding. John was an artist and enjoyed fine images, but the most mundane and imperfect photograph was valuable to him if it achieved its purpose. That purpose was most often the investigation, documentation, and communication of issues of cultural vitality and identity, which he saw as the core of the human condition.

John Collier, Jr., was born in 1913 at Sparkill, New York. He was youngest son of Lucy Wood Collier and John Collier, Sr., a social activist involved with community organizing in immigrant neighborhoods of New York City and with experiments in alternative schooling. Political changes following World War I led to the collapse of the national community center movement with which these efforts were associated, and the family moved to San Francisco in 1919. The following year, at the invitation of Mabel Dodge Luhan, they went to Taos, where they were immediately entranced by both the landscape and Taos Pueblo. The Colliers were soon introduced to ongoing local and national political controversies involving Pueblo religious and land rights, and the visit became a turning point in family history, as John Sr. applied his considerable skills as an organizer to these disputes, beginning an involvement in American Indian issues that led to his serving as United States Commissioner of Indian Affairs from 1933 to 1945.

These events had particular impact on John Jr., who was then seven years old. His father's advocacy work required movement between New Mexico and California, so the family established a home in Mill Valley (across the Golden Gate from San Francisco) and continued to spend large portions of each year in Taos, where John Jr. occupied his time at Taos Pueblo and in surrounding communities. Later, he defined his childhood in terms of Taos and California, seeing New York as almost irrelevant. The early experience with Pueblo and Spanish-speaking people of New Mexico profoundly shaped his interests and views of the world, forever changing his perceptions of culture and ethnic communities.

Accidents John suffered shortly after arrival in Mill Valley resulted in hearing loss and learning disabilities that grew progressively worse throughout his life. These prevented the successful completion of his schooling beyond an elementary level, although he continued to attend classes into high school. When John was about twelve years old, he was apprenticed to Maynard Dixon, a well-known painter, in the hope that training as an artist would provide opportunities that ordinary schooling could not. John lived for periods of time in Dixon's home, in the company of Dixon's wife, the

13. **Dentist performing an extraction in the clinic of the Taos County Cooperative Health Association. Questa, January 1943**

14. **Self-portrait and family "shrine" in a Pueblo home. Near Peñasco, 1957**
Collection of Mary Collier

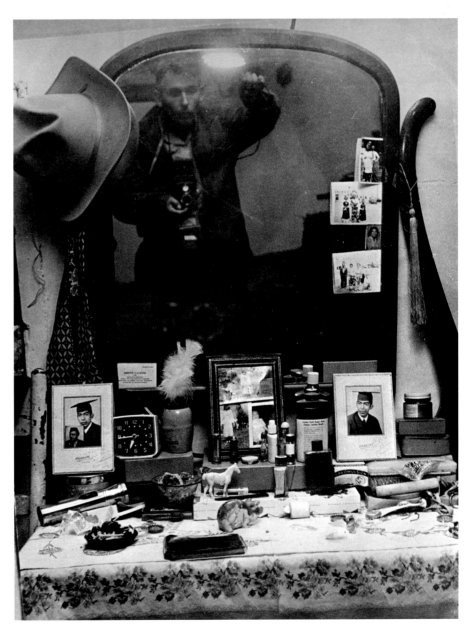

photographer Dorothea Lange, and their children. His association with the Dixons and his involvement with painting brought him into contact with the art communities of San Francisco and Taos, connections he maintained throughout his life. Dixon and Lange also reinforced the Collier family's tradition of social action. John received less formal art instruction from a number of Taos artists, notably Nicolai Fechin.

In Mill Valley, John encountered another tradition that shaped his outlook. A neighbor, Capt. Leighton Robinson, was a retired British master in sail who introduced him to maritime traditions and skills. Beyond establishing John's lifelong interest in the sea, Captain Robinson also passed on the dedication to detail, practicality, and hard work that was the ethos of working sail. This discipline and an associated voyage to Europe as a crew member of a sailing ship had a powerful impact on John's work habits throughout his life.

On his return from this sea voyage in 1930, John divided his time between Taos and the San Francisco area, his painting including mural work for the WPA. An interest in social action and documentation as well as a need for gainful employment drew him gradually from painting to photography. He had become familiar with photography through his contact with Dorothea Lange, and had spent considerable time with Paul Strand in New Mexico during the early 1930s, gaining exposure to the work habits of this exceptionally disciplined photographer. John's training was informal, but

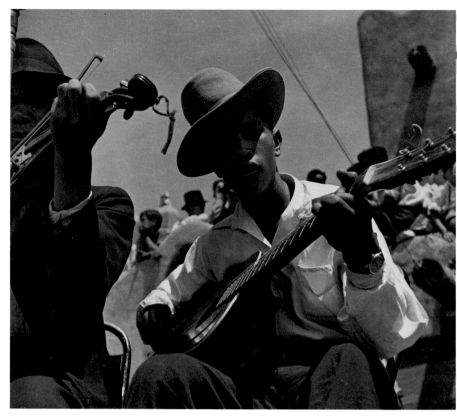

at some point Sara Higgins Mack and her husband, Robert, taught him the skills of studio and commercial photography. This instruction took place in San Francisco, although Sara was a Taos connection, the daughter of the well-known artist Victor Higgins. In other respects, John was largely self-taught, and his photographic style was completely his own.

15. **Musicians at a fiesta. Taos, about 1938**
Collection of Mary Collier

16. **Sheep belonging to Blas Chavez. Cordova, February 1943**

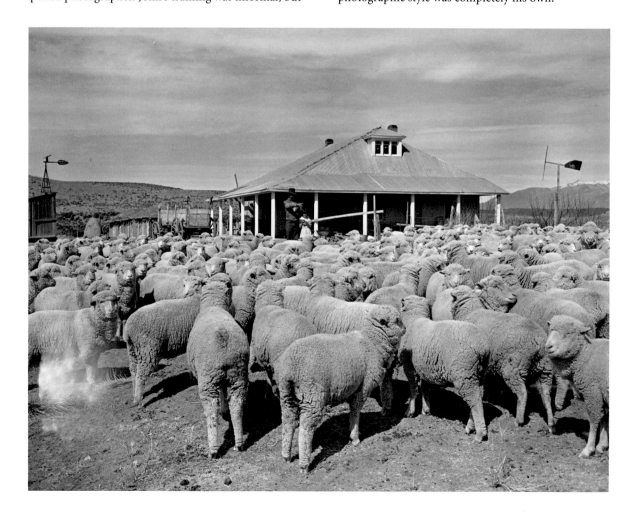

Between 1936 and 1941 he worked in both New Mexico and California. His assignments were varied, including photographs for and of artists, documentary recording, advertising, portraiture, and other studio productions. He operated a studio in Taos, using Paul Strand's old darkroom, and worked independently and for larger studios in San Francisco. Negative and print files from this period indicate an early interest in social and cultural documentation, including stories on a black Jamaican fisherman in Monterey, California; adobe making and construction in both California and Taos; and other New Mexican subjects, among them a wheat harvest and threshing in Talpa; fiestas in Taos (fig. 15); a rock crystal mine; cotton farming in the southern part of the state; and an extensive story on a sheep-ranching operation in Atarque. He made progressive improvement, both technical and conceptual, as he felt his way toward organized photographic documentation, but these formative documentary efforts do not appear ever to have generated much income. Early in this period he established a home in Rio Chiquito (Talpa) near Taos, which would serve as a base the rest of his life.

Presumably through the influence of Dorothea Lange, John's New Mexico work, especially the Atarque study, came to the attention of Roy Stryker, then head of the Historical Section of the FSA, and Stryker hired him as a photographer in 1941. John was in San Francisco at the time, and claimed to have received a phone call from Stryker while working in the darkroom of a commercial studio. According to the story, owing to his hearing problem, John handed the phone to his boss, who listened briefly and then told him: *Some fool in Washington wants to hire you as a photographer for $125 a month. You better take it because you're fired.*

FSA employment led to a variety of assignments from 1941 to 1943 and brought John into contact with many of the other FSA photographers, including Russell Lee, John Vachon, Jack Delano, Marion Post Wolcott, Ben Shahn, Walker Evans, Gordon Parks, Arthur Rothstein, Edwin and Louise Rosskam, Esther Bubley, Marjory Collins, Carl Mydans, and, of course, Dorothea Lange. Through some of these contacts, in 1943 John met and married Mary Elizabeth Trumbull of Schenectady, New York. The intellectual and professional consequences of their marriage were significant. Most people were aware of John's hearing problems, but few appreciated the frustrations of his other disabilities when dealing with the spoken and written world. Mary not only became an excellent photographer in her own right, but she was also the record keeper, editor, critic, and interpreter who enabled John to articulate in more conventional intellectual forms the perspectives and insights that were already being reflected in his photography.

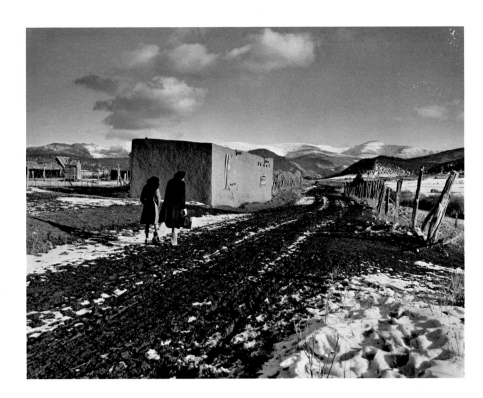

The FSA work laid important foundations for his later career. Regular assignments sharpened his technical and fieldwork skills, while exposure to the FSA files and contacts with the other photographers broadened his conception of photographic possibilities. Stryker's instructions and concern with the larger social and economic context encouraged a systematic approach to photographic fieldwork and a focus on photographs as information. FSA employment also provided John with credentials and credibility, which were particularly important to him in light of his disabilities and lack of formal schooling.

17. **Marjorie Muller, nurse from the clinic of the Taos County Cooperative Health Association, with an interpreter, leaving the ambulance to reach a patient's house beyond passable roads. Llano Quemado, January 1943**

18. **Spanish-American rancher. Chacon, January 1943**

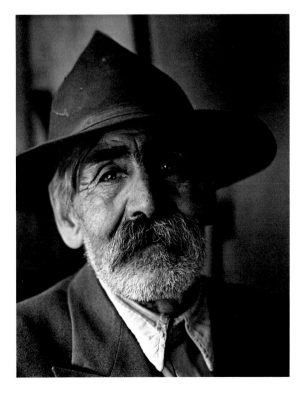

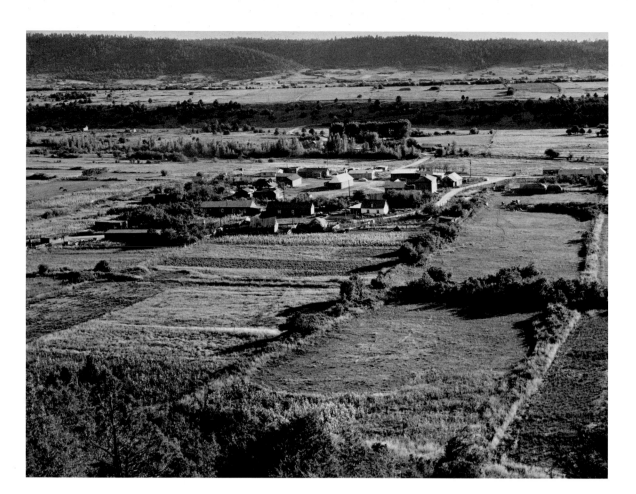

On the other hand, John came to the FSA from an unusual social and cultural background, which influenced his government work and had even greater impact on his later career. When he started with the FSA in 1941, his father was already twenty years into an effort to reshape government policy toward American Indians from one of assimilation to one of dynamic self-determination and cultural maintenance. John Jr. felt that his father failed to recognize his accomplishments or accept his disabilities, but the two men shared an overwhelming passion for the importance and value of ethnic minority communities. This perspective affected John's FSA work among the Amish, the Acadians, and the Spanish Americans. Though most people would have seen these groups as curiosities, John was predisposed to see them as significant, vibrant peoples with a future.

Moreover, he was not a visual novice. His training with Maynard Dixon and subsequent experience as a painter had already provided a strong sense of form and light, which was reflected in his photographs. Dixon, Lange, and the art world of San Francisco in the 1930s had introduced John to the concept of socially concerned art, an idea congruent with the FSA mandate. His disabilities had limited his capacity to engage in more conventional forms of social action and had helped prompt his move to a photographic career. The FSA experience served to confirm his decision to shift from painting to photography, which would become the vehicle for transcending his limitations.

John's FSA photographs from New Mexico were made late in his tenure with the agency. Stryker had kept him busy in the eastern part of the country, and seems to have been reluctant to have him work in New Mexico. Correspondence suggests the trip originated with suggestions from John, including an idea for photo-

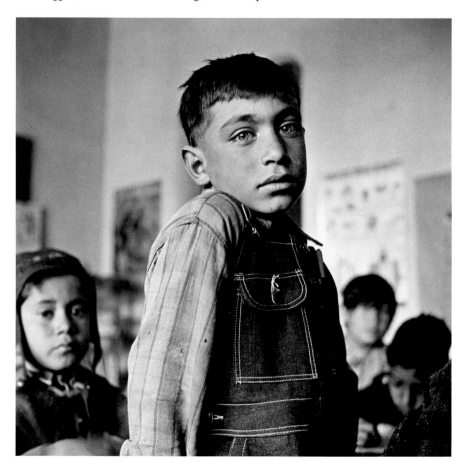

graphing at Taos Pueblo, which he must have known would be impossible. He was probably laying out all the bait he could think of to get the trip approved, although Stryker claimed to have been less than enthralled with the idea of photographing Indians. Beyond evident homesickness, John may have wanted an opportunity to record for the FSA a section of the country that was emotionally important to him, and to continue his earlier documentary efforts in New Mexico.

The New Mexico assignment placed John, as an FSA photographer, in the unusual position of working in his home territory. Though his associations with Taos Pueblo were of no photographic importance because the Pueblo, predictably, had no interest in photography, he was well placed in the region. Prior photographic work had given him contacts within the business community, and both early friendships and his work as a painter tied him to the artists of Taos. Since 1936 he had made his home in a rural Spanish-American community, establishing close relationships with a number of families. FSA credentials supplied access to government agencies and programs. John's connections crossed cultural and social boundaries in what was, and still is, a culturally and socially compartmentalized region. It is difficult to assess the impact of this position on his photography, but it must have facilitated his work, and certainly provided insight into local circumstances.

The winter of 1942 and 1943 was not the best of times for Taos County. Though New Deal–related programs during the late 1930s had, in John's view, created a sense of energy and optimism in the region, this was now overshadowed by the arrival of war. Taos and other counties in northern New Mexico were particularly affected because local National Guard units had been sent to the Philippines prior to the entry of the United States into the war, with the consequence that American casualties during the first months of fighting fell disproportionately on these few, sparsely populated counties. Enlistments and the draft had removed most younger men from the villages, so few appear in John's photographs. He reported to Stryker that the war had thrown a greater shadow over communities in Taos than in the other regions of the country in which he had worked.

Winter, though photogenic, was not the best time to record the life of the villages. It was a quiet time of the year, with ranching and farming activity at a reduced level. The winter was relatively mild, but getting around Taos County was still difficult; most of the roads were dirt, and many were not graded following snowstorms. This may have been an advantage to John in some cases, as it forced him to stay in the homes of a number of his subjects in Peñasco and Trampas, where he made the best photographs of his trip.

21. **Grade school teacher ringing a bell to call her class. Trampas, January 1943**

John arrived in the area shortly before Christmas and left early in March; he made most of the photographs in less than two months and organized them into fifteen sets, not all of them being complete stories. He recorded throughout the region, but did the bulk of his photography in the vicinities of Questa, Ranchos de Taos, Peñasco, and Trampas. His subjects were varied:

22. **Doorway of the general store. Trampas, January 1943**

landscapes, fields, corrals, villages, exteriors of homes and stores, home interiors, schools, churches, and government clinics. These images provided context for his photographs of people and activities, including stories on the home and daily life of a family in Trampas; the activities of Catholic priests in Peñasco and Questa; a ranch family in the Moreno Valley; schools in Peñasco, Ojo Sarco, and Questa; the traveling county medical clinic and doctor; and a public health nurse (figs. 17, 20, 21, 26, 27, 29–30). John also made partial records of religious services, the operations of several stores, a blacksmith shop, a gunsmith, a forest ranger, a food-rationing program, and a sheep ranch, as well as numerous portraits of people from many locales (figs. 16 and 22).

Many of John's FSA photographs have parallels in his earlier images of New Mexico. Everyday work scenes, studies of buildings and villages, church events and processions, and, especially, strong portraits are all found among the earlier pictures, which also include some photographs from Peñasco, Trampas, and Truchas. The style of coverage in the Atarque study of 1939 was particularly similar to that of the later FSA work. However, except for the Atarque story, John's earlier photographs do not include strong landscapes, particularly not those that define broad vistas and land use patterns. This absence is surprising because landscapes were one of the subjects of his paintings, and significant because such photographs comprise some of his most impressive later work and are presented as methodologically important in his writing on visual anthropology. Perhaps John's earlier FSA work had taught him the value of landscapes as records of social and ecological circumstances; in any case, landscapes

make up some of the most interesting, and most frequently overlooked, photographs that he made in New Mexico (fig. 19).

There were other new elements as well. John was now producing a much greater volume of photographs, in part because the government provided supplies, in contrast with prior projects, which he had done *on spec*, out of his own pocket. In addition, the technical quality of his FSA photographs was higher, and the stories more carefully planned and shot. Stryker had introduced the idea that photography could be shaped by a structured methodology, but for John this was just the beginning; the FSA approaches pale in comparison with methodologies he would later develop in visual anthropology.

Access to flash equipment and bulbs produced impressive photographs of indoor family and work subjects not seen before. John was now applying to his own, well-defined sense of light and form the technical expertise he had learned from such masters of lighting as Russell Lee. This accomplishment was remarkable because in those days the mathematical calculations normally required for such work were utterly beyond John's abilities and comprehension. Among the interior photographs were extensive records of home styles and decor, precursors of what would later be called *cultural inventories* (fig. 14).

When John returned to Washington in March 1943, he was still exploring how the vehicle of photography

23. **Boy standing in front of a picture representing "balanced" farm life, which did not exist in his area. Peñasco, January 1943**

24. **Former gold- and copper-mining center. Elizabethtown, February 1943**

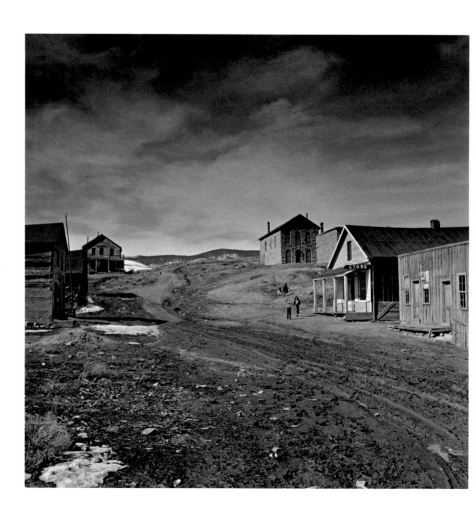

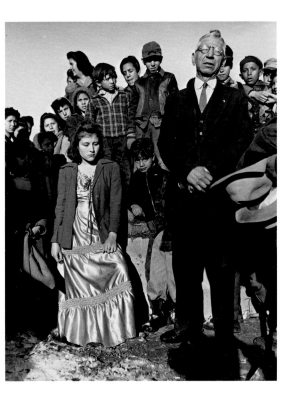

might enable him to achieve his goals. Significantly, the strongest sets of photographs shot during the two-month period in New Mexico – those of Spanish-American families and communities – are the ones that most closely anticipate his later work in visual anthropology while also reflecting a continuation of his earlier interests. Of all the photography John did for the FSA and the OWI, it was his work in New Mexico and among the Amish, the Acadians, and the Portuguese-American fishermen – all involving ethnic minorities within the larger society – that he remembered most fondly. Though it would be some years before he articulated in written form his interest in

cultural energy and vitality, his photography reflected these concerns almost from the beginning.

In addition to his work for FSA, John made many other images in New Mexico, continuing to photograph in the Southwest throughout his life. Many of the pictures were more personal in character, but there were also numerous formal documentary projects,

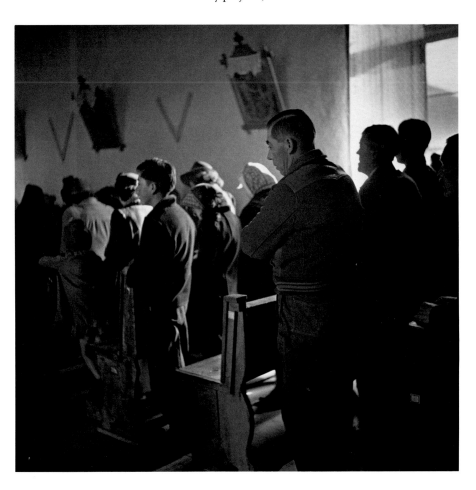

including records of the school and community of Cebolla in 1950; photographs of a field project in Truchas in 1952, with associated photographs from the Papago and the Navajo reservations (later published in *The First Look at Strangers* by Robert Bunker and John Adair)[1]; photographs made from 1938 to 1972 of a large variety of subjects on the Navajo Reservation; a photographic study of Peñasco and Picuris in the late 1950s; color photographs from Ranchos de Taos of the last full-scale performance of a folk pageant commemorating the famous battle between New Mexican forces and the Comanche in the eighteenth century; and a large body of images of people, life, and activities in the Taos region.

In 1944, following a period of wartime service in the merchant marine, John went to work for Stryker again, this time for the Standard Oil Company. He was sent first to the Canadian Arctic and then, in 1945, to South America, to photograph oil development; however, he more often turned his camera, with Stryker's encouragement, on a wide range of social subjects and community action, much of which had little to do with oil.

25. **A *santo bulto* and a painting of the *Dolorosa*. Trampas, January 1943**

26. **Mass. Questa, February 1943**

27. **Justice of the peace making a speech at the dedication of the new clinic building of the Taos County Cooperative Health Association. Peñasco, January 1943**

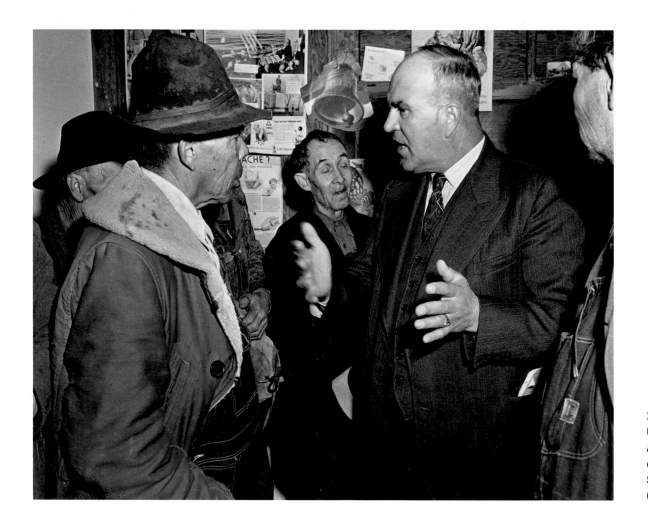

28. **Representative of the United States Agricultural Adjustment Administration explaining farm plan to Spanish-American ranchers. Chamisal, January 1943**

In this capacity John and Mary worked in Venezuela, Colombia, Ecuador, and Peru from 1945 to 1947. In addition to their work for Stryker, they independently collaborated with an Ecuadorian anthropologist, Anibal Buitrón, on an ethnographic documentation of the Indian community of Otavalo, Ecuador. This work, which was published in 1949 as *The Awakening Valley*, represented an increasing interest in the use of photography as a tool in social research, and was the first deliberate step John and Mary took toward the development of field methods in visual anthropology.[2]

Returning to the United States in 1947, they entered a period of varied photographic activity, operating out of both Taos and New York. They worked for various magazines, including *Fortune* and *Farm Quarterly*, and for Standard Oil on a free-lance basis, as well as pursuing independent documentary efforts and projects in association with social scientists, primarily in the Southwest and in Nova Scotia. Much of this latter work was done in association with Cornell University, bringing John and Mary into contact with Alexander Leighton and other major figures in anthropology. Leighton, in particular, introduced them to the demands of scientific investigation, and challenged John to develop specific methodologies for the use of photography in anthropological research. Photographs made during this period show John's increased sensitivity to the subtleties of social process.

The Cornell connection took John and Mary, now with three sons, back to Peru in 1954, to work on the Vicos project with Allan Homberg. They spent a year making a complete visual ethnography of Vicos as well as documenting the progress of a community development project that Homberg directed. Though this was, without doubt, the most extensive and intensive photographic project of John's career, it has, unfortunately, remained largely unpublished.

John and Mary spent the period from 1955 to 1958 in New Mexico, using a Guggenheim Fellowship to organize the exploratory work in visual anthropology and engaging in free-lance photographic work. In 1959 economic need took the family to California, where they established a home at Muir Beach, in Marin County, although they still spent several months of each year in New Mexico. In California John initiated a long teaching career, taking on assignments at the California School of Fine Arts (now the San Francisco Art Institute) and later at San Francisco State University, where he taught visual anthropology and cross-cultural education. Teaching offered a proving ground for John's ideas for the use of photography in anthropology and led to the formal articulation of his concepts and methodologies in the landmark book *Visual Anthropology: Photography as a Research Method* (1967), a pragmatic guide to the systematic use of photography as a tool to record and analyze cultural and social cir-

cumstances; this was very much the collaborative product of John and Mary. Expanded and revised in 1986, it remains the primary field methods text in the discipline.[3]

However important John's work in photography and later in cross-cultural education may be, his role in developing the field of visual anthropology remains his most important accomplishment. *Visual Anthropology* was the first major exposition of the application of photography to anthropology and the social sciences, and was the culmination of an exploration that had formally begun with Buitrón in 1946, but that had earlier roots, including the FSA. The importance of John's experience in the FSA is reflected in his dedication of the first edition of *Visual Anthropology* to both Roy Stryker and Alexander Leighton. The FSA had introduced John to a number of the elements of what would become visual anthropology, including the most important concept of all, that photographs contain information that may be of value to the social scientist and policy maker. The FSA taught John the importance of routine recording of a wide range of often mundane subjects as part of a systematic, interconnected process of social documentation, as well as the value of equally systematic handling of images after they were made.

Stryker and the FSA experience were important, but alone they might simply have served to make John a better photographer. Other facets of his experience, most especially his family background and his childhood in New Mexico, provided him with the perspective to see the potential importance of applying photography to the understanding of cultural processes. His anthropological contacts and associated fieldwork supplied the knowledge that enabled him to transform solid documentary photography into sound research methodologies.

In the 1960s John continued his photography with documentation of Indians in rural and urban settings in California, and began to use motion picture film as a documentary/research tool. In 1969, he expanded his work into the field of anthropology and education, using film to record and analyze the quality of schooling for Alaskan Native children. The results were later published in *Alaskan Eskimo Education: A Film Analysis of Cultural Confrontation in the Schools.*[4] This publication reflected not only further refinements of visual anthropology but also John's long concern with cross-cultural education and the cultural self-determination of ethnic minorities. His research played an important part in the creation of new programs to train Native teachers in Alaska, and during the 1970s he followed it with extensive film research projects on the Navajo Reservation and in urban schools in California.

Throughout these years, John continued to teach,

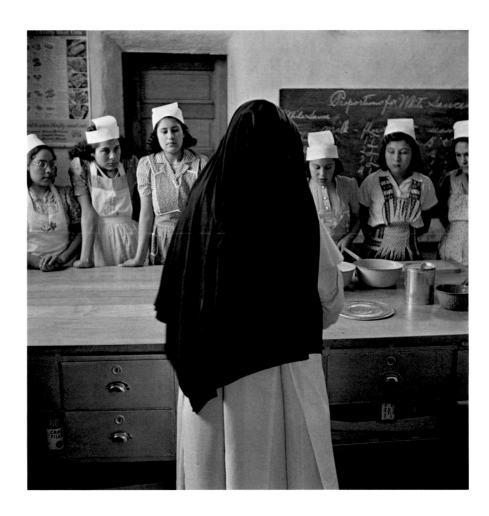

gaining a reputation as a warm and unorthodox teacher who transmitted to his students both new ideas and a concern for the human condition. He retired from teaching in 1989, and died during February 1992 in San José, Costa Rica.

John's life and career were ultimately shaped by a driving concern with cultural vitality and identity, which he viewed as the foundation of human experience. Photography was his means to address these issues and was central to all the major accomplishments of his life – the development of visual anthropology, the articulation of important perspectives on cross-cultural education and community development, and more than twenty years of teaching these skills and perspectives to students of photography, anthropology, and education. He drew great pleasure from the fact that use of the camera as tool could also produce great photographs. Indeed, John found distinctions between art and science often meaningless, and he crossed those boundaries, as well as those of several cultures and of his own disabilities, to produce new ways of seeing and a legacy of extraordinary photographs of places and people in the Americas.

29. **Domestic science class in a high school supported by the state but administered by the Catholic church. Peñasco, January 1943**

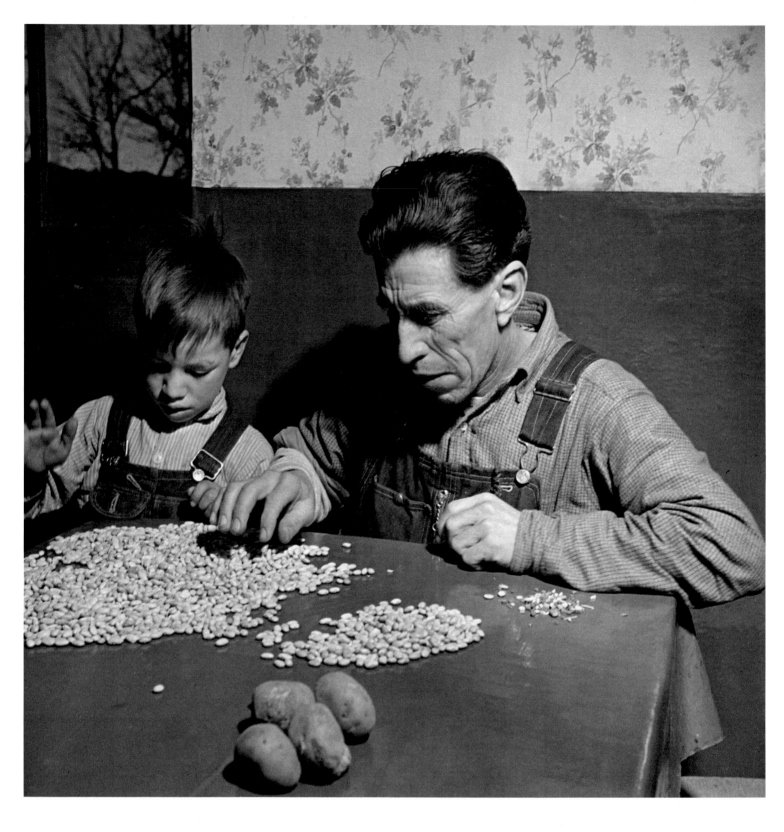

NOTES

1. Robert Bunker and John Adair, *The First Look at Strangers* (New Brunswick, New Jersey: Rutgers University Press, 1959).

2. John Collier, Jr., and Anibal Buitrón, *The Awakening Valley* (Chicago: University of Chicago Press, 1949).

3. John Collier, Jr., *Visual Anthropology: Photography as a Research Method* (New York: Holt, Rinehart and Winston, 1967); John Collier, Jr., and Malcolm Collier, *Visual Anthropology: Photography as a Research Method*, rev. ed. (Albuquerque: University of New Mexico Press, 1986).

4. John Collier, Jr., *Alaskan Eskimo Education: A Film Analysis of Cultural Confrontation in the Schools* (New York: Holt, Rinehart and Winston, 1973).

30. **Juan Lopez, the *majordomo*, sorting beans for the morning meal. Trampas, January 1943**

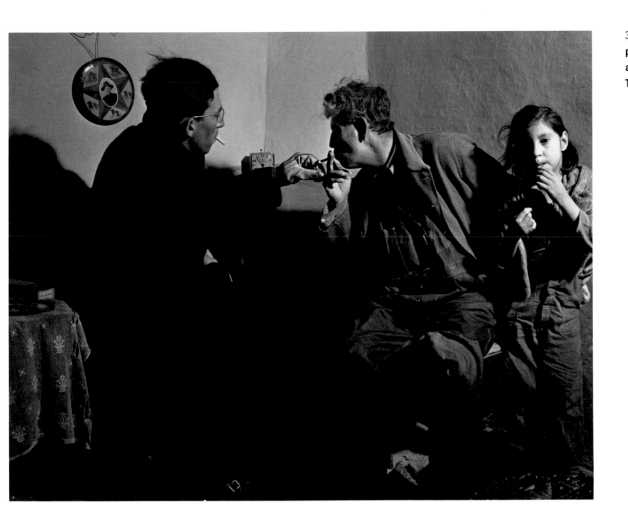

31. **Father Cassidy, parish priest of Peñasco, smoking and talking with a parishioner. Taos County, January 1943**

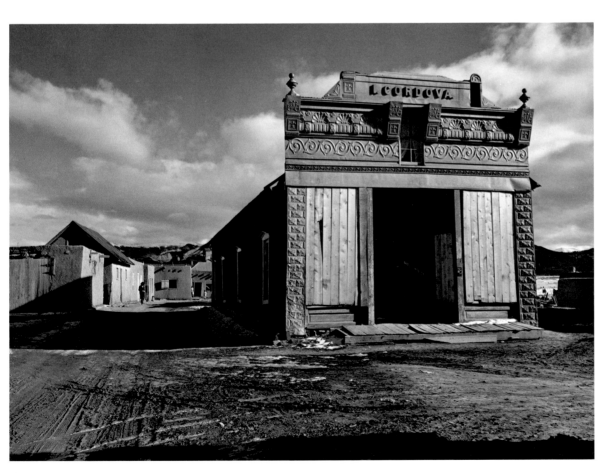

32. **Abandoned building. Truchas, January 1943**

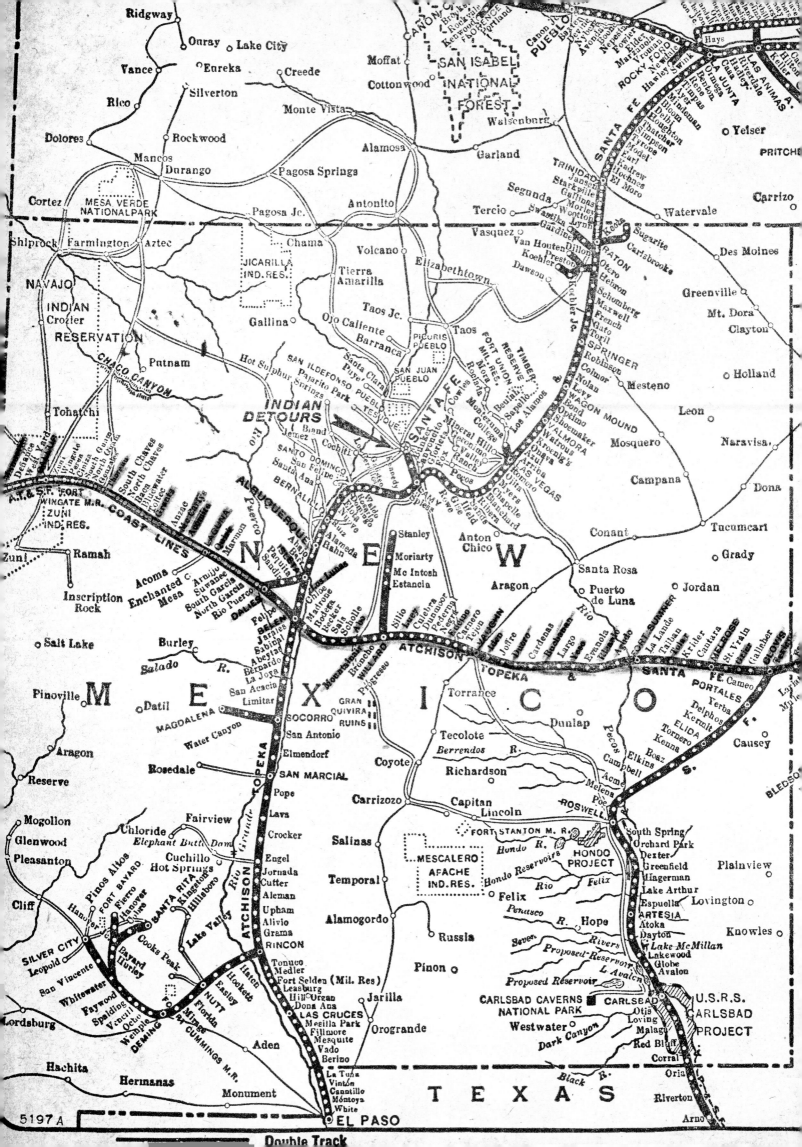

Jack Delano and the Railroad Photography Project in New Mexico

Jay Rabinowitz

I don't know that there were any rules for documentary photography. As a matter of fact, I don't think the term was even very precise. So as far as I'm concerned, the kind of photography I did in the FSA was the kind of photography I still do today, because it is based on passionate concern for the human condition. That is the basis of all the work that I do.[1]

The railroad brought Jack Delano to New Mexico in March 1943. While World War II was raging, this accomplished documentary photographer was given an assignment to chronicle the American railroad system. He worked for five weeks on the rails between Chicago and Los Angeles for the OWI, which was headed by Roy Stryker, former director of the Historical Section of the FSA. Stryker sent Delano to portray the readiness of the national railroad system to support the war effort.[2]

After a decade of neglect during the Great Depression, the railroads were in disrepair. Increased demands for domestic freight, as well as military orders to supply troops overseas, overburdened existing resources. Masses of people and great quantities of machinery, materials, and foodstuffs were being transported across the country. New Mexico played a significant role in this vital system. From the plains of Kansas, steam-powered freight trains traveled through Clovis, New Mexico, avoiding the mountains and severe weather of Colorado and northern New Mexico on their way to Pacific coast depots. Modern diesel engines were used to power trains through desert terrain west of Gallup, New Mexico, through Arizona, and on to California. Heavy rail traffic, essential freight loads, the endless changing of engines, and ongoing maintenance made the rail facilities in New Mexico fundamental to the war effort.

To complete his assignment Delano drew upon his experience with two Depression-era agencies. He had already created penetrating photographic documents for the WPA and the FSA in order to help focus public attention on economic and social troubles in the United States. In New Mexico, as in the rest of the nation, government photographers had discovered a regional resolve, threads of the diverse fabric that had kept America going during the Depression.

The Railroad Photography Project, however, presented a dilemma in its implied patriotic promotion, which contrasted starkly with projects that documented the struggles of existence. Delano was assigned to make pictures that showed industrial strength rather than personal hardship. As a photographer, he believed in expressing human values through the dignity of work and in fair treatment of the disadvantaged: *I was interested in people not only as images, but also as human beings. In stories that they would tell me or interviews I had with them. It seemed to me it was an important part of what I was trying to communicate.*[3] In his images for the Railroad Photography Project, he documented with depth and compassion the efforts of those who supported the life of the railroad during the war.

Jack Delano was born Jack Ovcharov in Kiev, Ukraine, on August 1, 1914. He emigrated to America with his family in 1923, settling in Philadelphia. As a member of a lower-middle-class family, he depended upon scholarships to fund his education. Music and art were his primary interests, and he studied violin, viola, and composition at the Settlement Music School from 1925 to 1933. In 1932 he pursued drawing and painting at the Pennsylvania Academy of Fine Arts. During summer studies as a Cresson Travel Scholar in 1936, Delano went to Europe, where he purchased an inexpensive camera. After returning home, he joined a National Youth Administration project and bought a better camera, continuing what would become a lifelong involvement with photography.

Fortunate in his education, considering his family's humble means and the impact of the Depression, Delano was faced with economic reality in seeking employment after he left school. In 1937 the young photographer proposed to the Federal Arts Project that he study and document the deplorable conditions in the coal mines of Schuylkill County, Pennsylvania. His proposal was accepted, and after several months an exhibition of his photographs was organized for the Pennsylvania Railroad Station Gallery in Philadelphia. He also produced two books of photographs to document this formative project.[4]

In 1939 Delano sent those books to Roy Stryker in Washington, D.C., along with a letter expressing interest in joining the FSA team of photographers. Several friends and acquaintances were already working for the government agency. Because many of the photographers were leaving the FSA at the time, Stryker immediately hired the promising young man.

Map of New Mexico, 1943
Delano highlighted the names of the places where he stopped and worked along the Atchison, Topeka and Santa Fe Railroad line. Collection of Jack Delano

Jack Delano, Chicago, 1943.
Photograph by Irene Esser Delano
Collection of Jack Delano

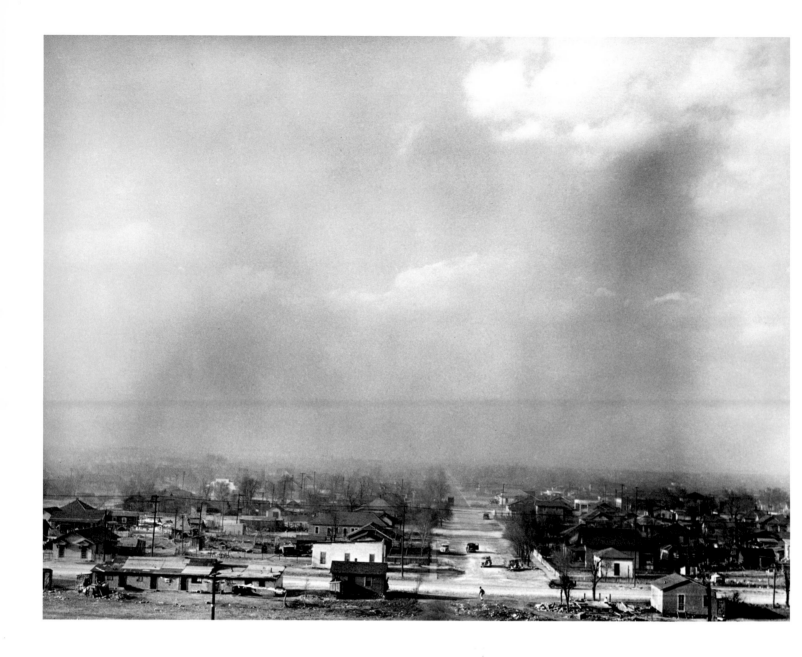

Delano went to work right away. He drove his car from assignment to assignment, sending back exposed film from one location and receiving fresh supplies and prints for captioning at the next. With their lengthy series of assignments, FSA photographers spent many months on the road before returning to Washington, usually receiving updated instructions by letter or telegram. Frequent correspondence from Stryker included objectives and suggestions regarding people and regions to be documented. The photographers replied with their own suggestions and with descriptions of their experiences.

Delano met the challenge with enthusiasm and commitment. He became known for his strong pictorial compositions as well as his sensitive approach to subjects. When asked about the connection between his fine arts training and his keen sense for social documentation, he replied:

They are certainly very closely connected. My interest in the fine arts was based on its interest as a means of communication [for portraying] social conditions. I often have been asked who my influences have been in photography, what photographers influenced my work. The truth of the matter is that it wasn't any photographer particularly, but it was rather the artists and painters whom I've admired so much. Artists who were interested in communicating, and who were interested in the lives of humble people. I'm thinking of people like Van Gogh and Bruegel, Persian and miniature prints, Japanese prints showing the life of ordinary people in town. It was these painters more than anyone else who influenced my approach to photography.[5]

Soon after the outbreak of World War II, the photographic unit of the FSA was transferred under the administration of the OWI. With matters of foreign policy taking precedence over the funding of social reforms, the agency came under increased government scrutiny, so the transfer saved the photographic unit. Stryker and his photographers were able to continue their work, but their assignments shifted from a systematic documentation of social conditions to photographic essays embracing the involvement of the United States in the war.

33. **Sand storm. Clovis, March 1943**

In November 1942 Delano received instructions to document the wartime freight rail system. He proceeded to Chicago, the largest hub of railroad activity in the country. After several months of photographing there, he set out for Los Angeles in order to view railroad operations along the most active transport lines.

Delano lived on the trains and in the towns along the Atchison, Topeka and Santa Fe railroad line. From Chicago he traveled west to the prairie states, south through Texas, and west again to New Mexico. On the way to Clovis he wrote a letter to his wife, Irene Esser Delano, describing how his attempts to find a subject with the camera were being challenged by the endless landscape: *We are heading due West and behind us the morning sun is blinding. Shiny rails go off in a straight line for the horizon. . . . Everything here is distance and I don't know how much of it I'll get but there really isn't anything else I can do. Our next stop will be Clovis N.M.*[6] A sand storm greeted Delano when the train pulled into town (fig. 33). Freight cars were filled with cars

carrying explosives, chemicals, motors, pipes, rivets, bomb fin assemblies, poultry feed, and hogs.

Many of these trains included forty to eighty cars and traveled daily through the arid New Mexican landscape. The scarcity of water necessitated the daily run of a special train of water tank cars from the small village of Vaughn. The Clovis station included facilities for repair and maintenance, where members of the United States Army Railroad Battalion were trained by experienced rail workers. Since most of the younger railroad men were already serving in the military, the army brought in new personnel to apprentice with senior tradesmen, and unions began employing unskilled men and women. People from all cultures who had been unable to find work before the war became assets in a wartime labor force. Delano found several African-American women cleaning out rail cars (fig. 34).

As the train moved from Clovis to Vaughn, the photographer recorded the experience in detail:

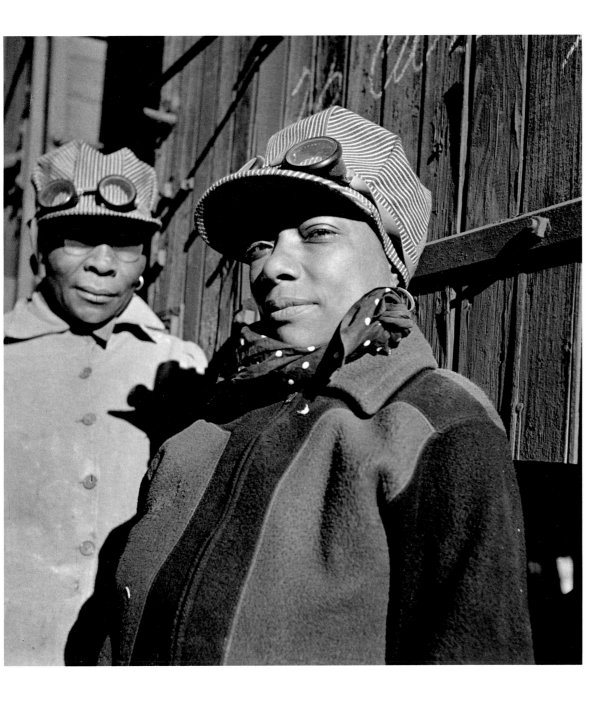

34. **Abbie Caldwell, employed in the Atchison, Topeka and Santa Fe rail yard to clean out potash cars. Clovis, March 1943**

Left Clovis 11:20 a.m. – arrived Vaughn 7:50 p.m. – 82 cars – 4141 tons – 11 stops made – met 13 trains – Total time on road 8 hrs. 30 min. – distance 131 miles.[7] Delays and heavy traffic allowed Delano the time to search the train inside and out for signs of life along the rails. A conductor's chair in a caboose set on glass casters impro-vised from old telephone line insulators provid-ed a telling symbol (fig. 35).

This stretch of rails needed maintenance regularly. In Iden, between Clovis and Vaughn, Delano pho-tographed a section gang of American Indians work-ing on the tracks (fig. 36). These workers lived in self-sufficient rail cars so they could travel from location to location and continuously repair tracks (fig. 40). Hopping another train to the small city of Belen, the photographer witnessed more of the diverse geography of New Mexico as the freight cut south to the Manzano Mountains, through the Abo Pass, and down into the Rio Grande valley.

After arriving in Belen, Delano took a short side trip to Albuquerque to see its rail yards, which con-tained one of the largest locomotive repair facilities in the nation. During the war this complex was of partic-ular strategic importance. It included a railroad tie plant that produced eighty thousand ties of pine and fir each month (fig. 37). The repair and maintenance shops worked round the clock, with tens of thousands of spare parts on hand. Each steam locomotive required a careful check of its nearly twenty-five thousand parts, and often needed complete dismantling and reassembly during overhauls (fig. 39).

About half the men who worked in these shops were Spanish Americans. The photographer encoun-tered families who had worked for the railroad through several generations. Everyone worked long, difficult shifts. A switchman commented: *You can't buy a day off now. It used to be you could lay off every-body for a while, but the very thing is now, they're short of men. They need you bad now.*[8]

After a few days Delano returned to Belen and

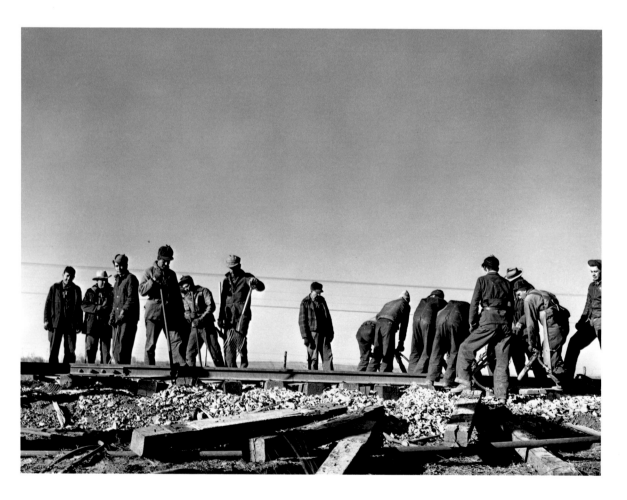

boarded another westbound train, continuing to photograph people and communities along the way. Near Gallup, he found a group of American Indians maintaining tracks as well as running small shops that served the railroad station. His notes reveal that the station employed about 20 Lagunas, *good workers, liv[ing] in village. Santa Fe has agreement with Laguna reservation to hire Indians preferentially in exchange for rights to get water at Laguna reservation* (fig. 42).[9] After Gallup, the photographer headed west to Arizona, and then to the end of the line in San Bernadino, California.

The Railroad Photography Project became an essential part of the government record about the vital role of domestic wartime transportation. Delano's photographs documented the steady commitment of the experienced and inexperienced men and women who worked to keep the freight trains moving in America. The photographer provided testimony to the perseverance of the American worker even as he expressed his capacity for a rich artistic vision.

After his work on the Railroad Photography Project ended, Delano served as a photographer for the Air Transport Command of the Army Corps of Engineers

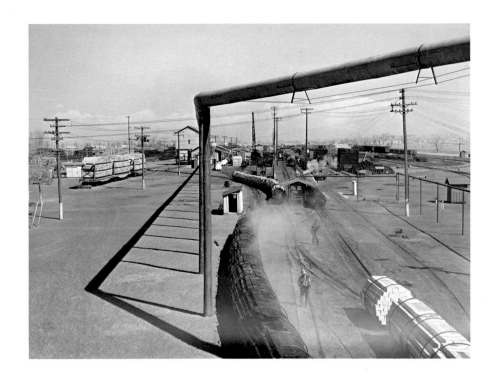

until the end of the war. He was then reunited with his wife, and they made their home in Puerto Rico, where they had worked together during an early FSA project.

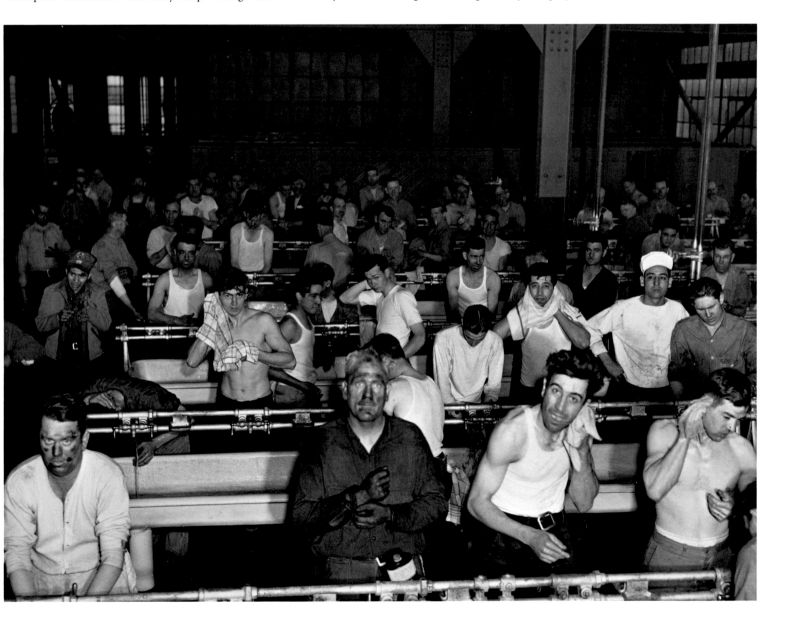

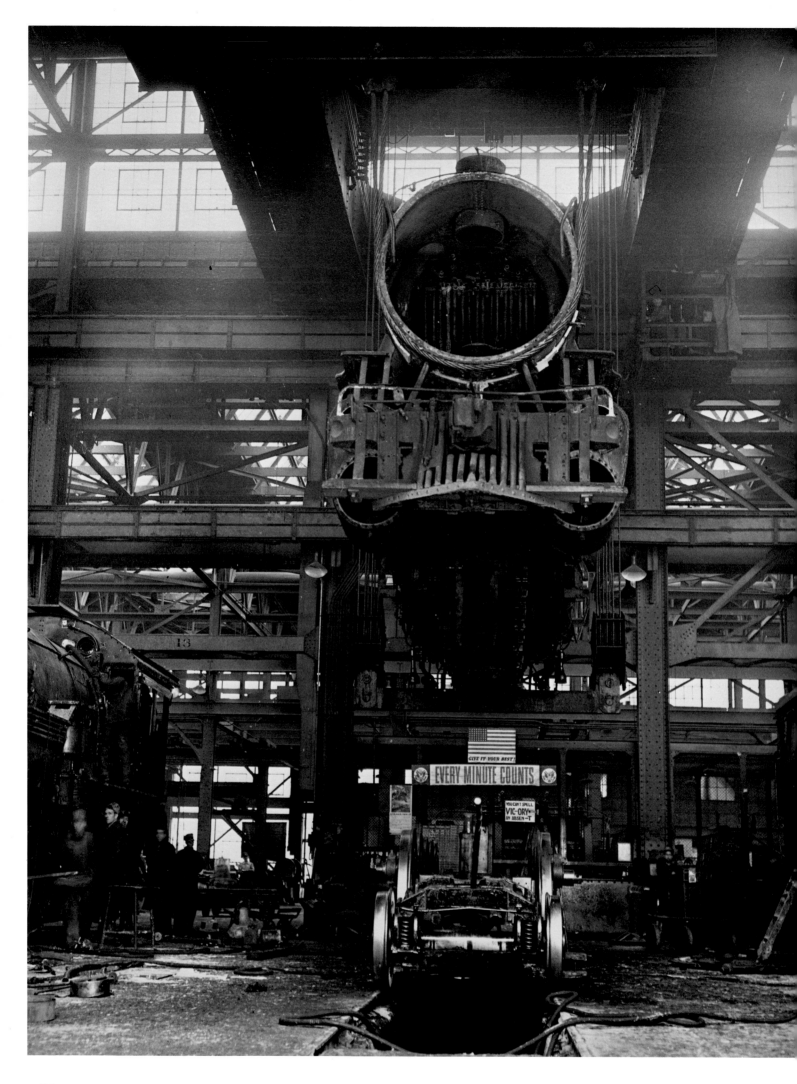

NOTES

1. Taped interview of Jack Delano by Jay Rabinowitz, January 5, 1993. Transcript, Museum of Fine Arts, Museum of New Mexico, Santa Fe, 3.

2. James E. Valle, *The Iron Horse*, 2nd ed. (Berkeley: Howell North Books, 1978), 5–6.

3 Delano/Rabinowitz interview, 1.

4. Taped interview of Jack and Irene Delano by Richard K. Dowd, June 12, 1965. Transcript, Oral History Collections, Archives of American Art, Smithsonian Institution, Washington, D.C., unpaginated.

5. Delano/Rabinowitz interview, 3.

6. Jack Delano to Irene Esser Delano, Amarillo, Texas – Clovis, New Mexico, March 18, 1943. Collection of Jack Delano.

7. Jack Delano, Railroad Photography Project Notebook, March 18–24, 1943, unpaginated.

8. Ibid.

9. Ibid.

10. Delano/Dowd interview.

39. **Engine in the Atchison, Topeka and Santa Fe locomotive shops. Albuquerque, March 1943**

40. **Bunk car for section workers in the rail yard. Iden, March 1943**

41. **In the railroad wheel shop. Albuquerque, March 1943**

42. **Ben Acory, an Indian employed at the railroad car shops. Gallup, March 1943**

There, the photographer continued his involvement in cultural and social services. Through a series of creative and administrative positions, he assisted in organizing government agencies in film, radio, and television.

Currently, Jack Delano continues his work and enjoys renewed interest in his photographs. In recent years, they have been the subject of several exhibitions, books, and articles honoring his perceptive vision. His lifetime of service to society is best characterized by his own words on his role as a government photographer:

Speaking for myself, I felt that I was part of an organization which was basically interested in the cultural values of America, which had nothing to do with politics but had to do with the American tradition, with the bad things, the good things, the difficulties, the problems, the joys and inspirations and everything that went with it. [10]

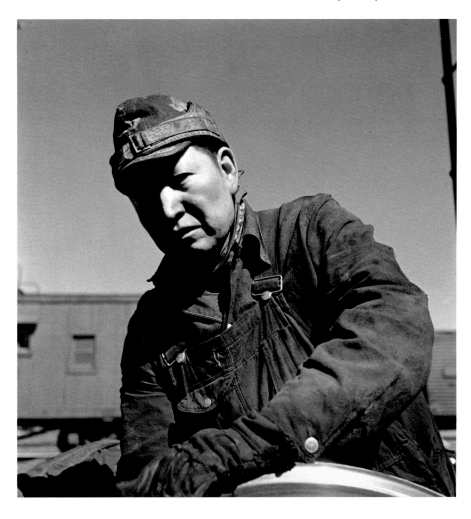

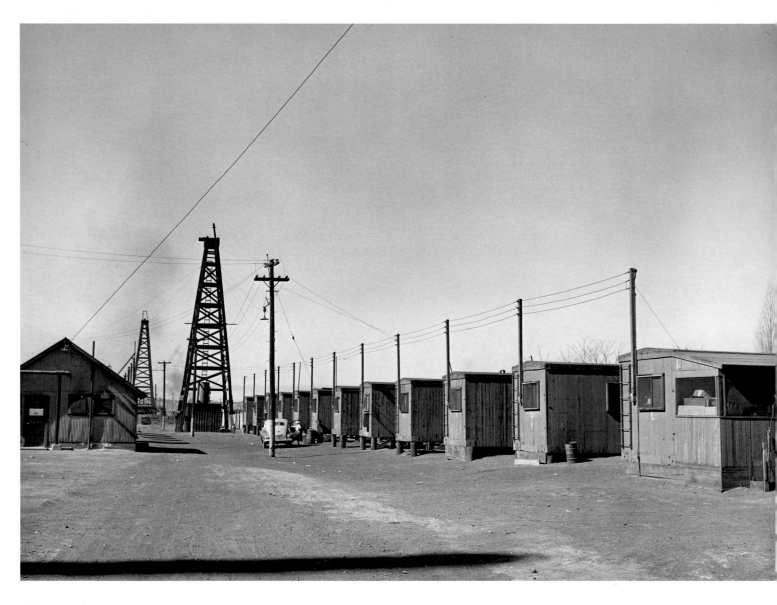

43. **Houses for the Indian and Mexican workers at the Atchison, Topeka and Santa Fe railroad shops. Gallup, March 1943**

44. **Passing a trainload of military tanks. Near Nelson, Arizona, March 1943**

Far from Main Street:

Photographs by

Russell Lee

Jack Delano

and John Collier, Jr.

45. **Workmen inspecting newly driven rivets in a flue sheet and boiler seam in the locomotive shops. Albuquerque, March 1943**
Photograph by Jack Delano

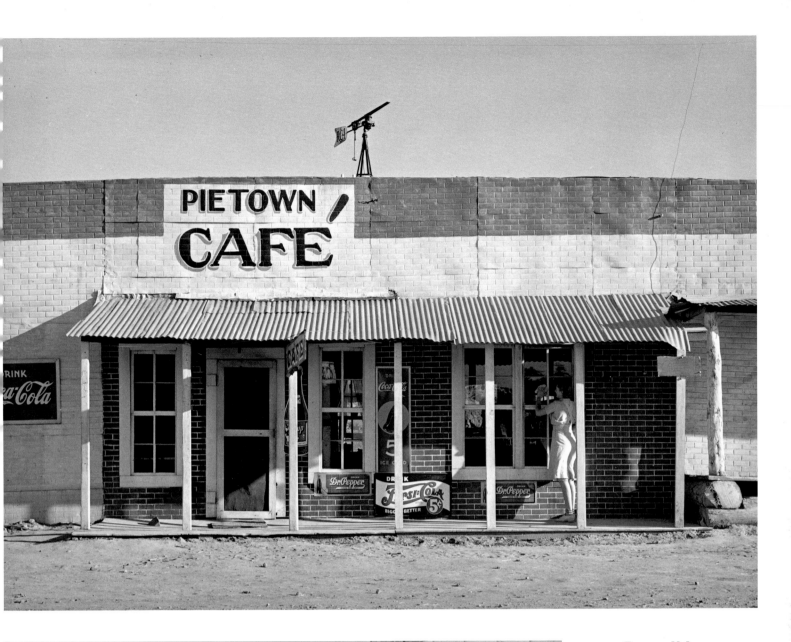

Russell Lee

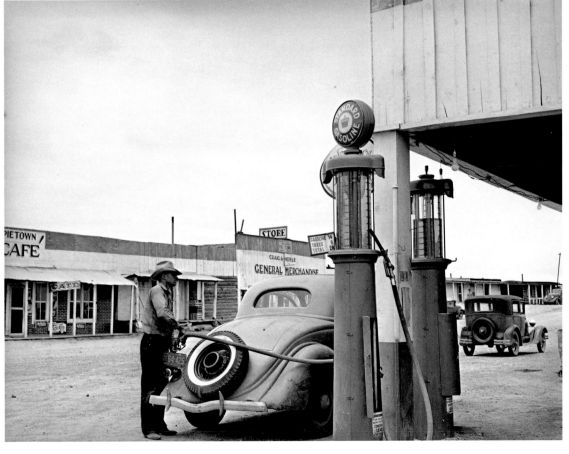

46. **Lois Stagg who, with her husband, rents and runs the cafe in Pie Town, a community settled by about 200 migrant Texas and Oklahoma farmers who filed homestead claims. Pie Town, June 1940**

47. **Cafe. Pie Town, June 1940**

48. **The gasoline pumps. Pie Town, June 1940**

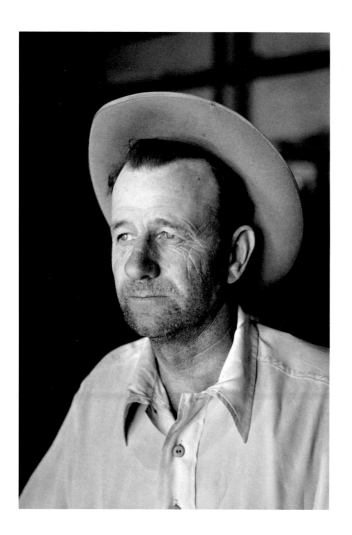

Arrived here yesterday evening after a trip thru about all the extremes you could imagine – windstorms, rain, duststorms, sleet, driving snow and finally tropical heat. From Albuquerque we went to Soccoro, to Datil, N. Mex.... Then we crossed the Continental Divide and on to Pie Town which is a settlement of migrants from Texas and Oklahoma – dry land farmers raising pinto beans and corn. Talked with the store owner there and I believe it should be one community we must cover. He called it the "last frontier" with people on farms ranging from 30 to 200 acres – some living in cabins with dirt floors – others better off, but all seemingly united in an effort to make their community really function.

Russell Lee to Roy Stryker, April 20, 1940

50. **Mrs. Whinery working in her kitchen. This picture shows the dirt floor of the dugout and the natural lighting. The original dugout house cost thirty cents for nails and took Jack Whinery ten days to build. Pie Town, June 1940**

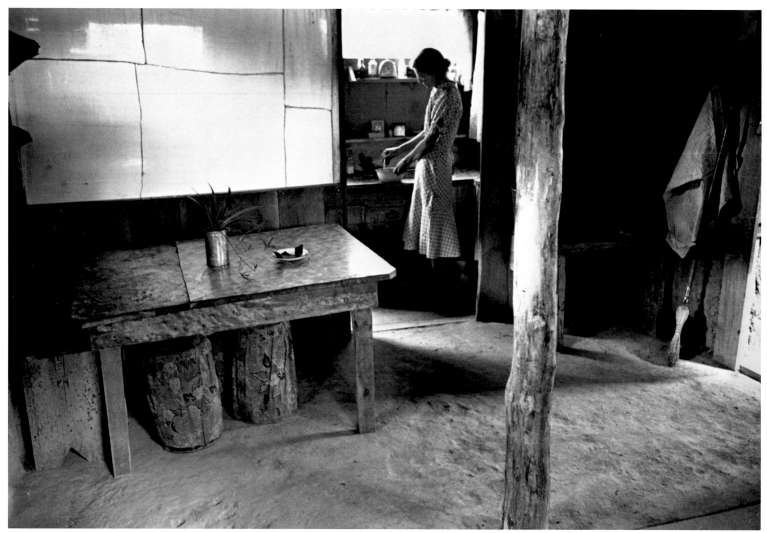

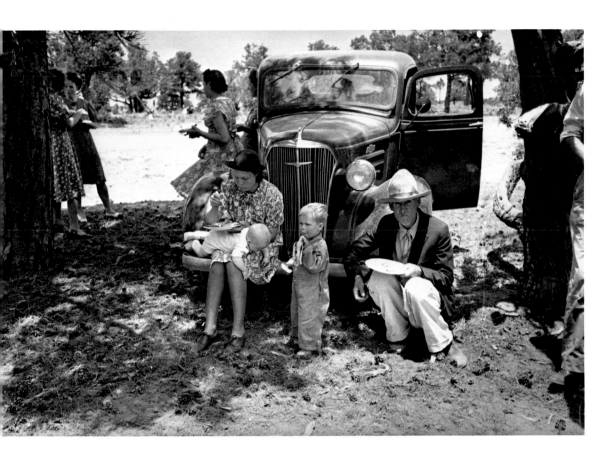

51. **Farm folks eating dinner
at the all-day community sing.
Pie Town, June 1940**

52. **Kitchen scene in Spanish-
American home, making tor-
tillas. Taos County, September
1939**

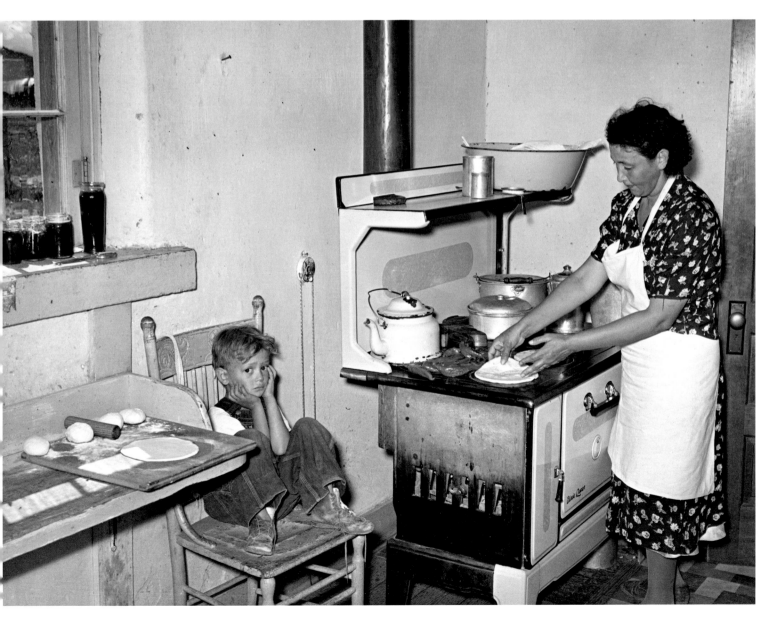

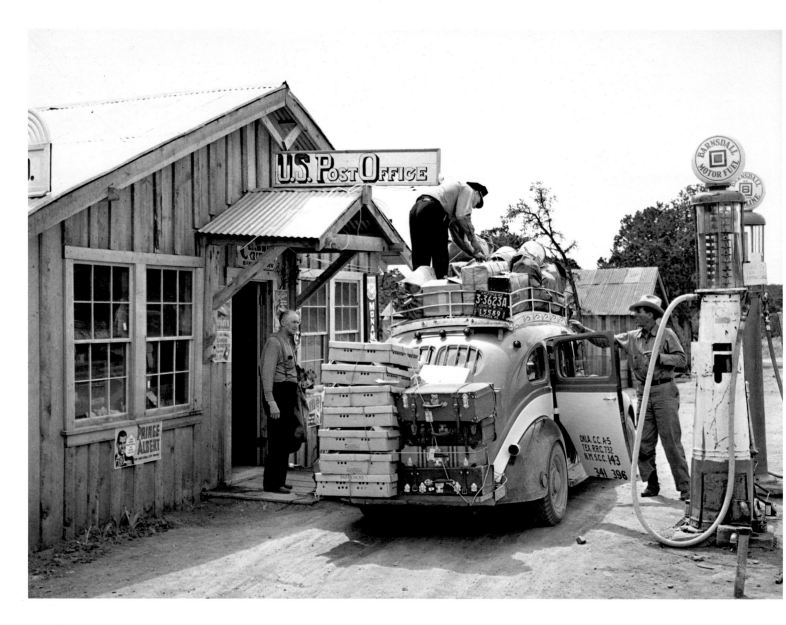

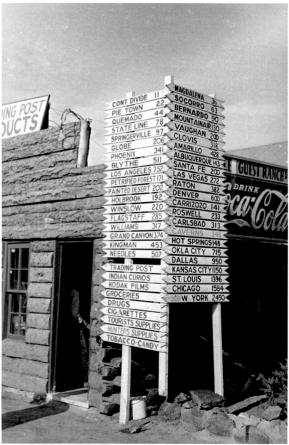

53. **Stage which daily brings the mail, freight, express and passengers. Pie Town, June 1940**

54. **A visitor at the fiesta. Taos, July 1940**

55. **Sign. New Mexico, 1940**

56. **Mrs. Bill Stagg with state quilt which she made. Mrs. Stagg helps her husband in the fields with plowing, planting, weeding corn and harvesting beans. She quilts while she rests during the noon hour. Pie Town, June 1940**

57. **Neighbor fixing the grocery clerk's hair. Pie Town, June 1940**

58. **Farmer and his brother playing a guitar and violin. Pie Town, June 1940**

59. **Children sleep while their parents square dance. Pie Town, June 1940**

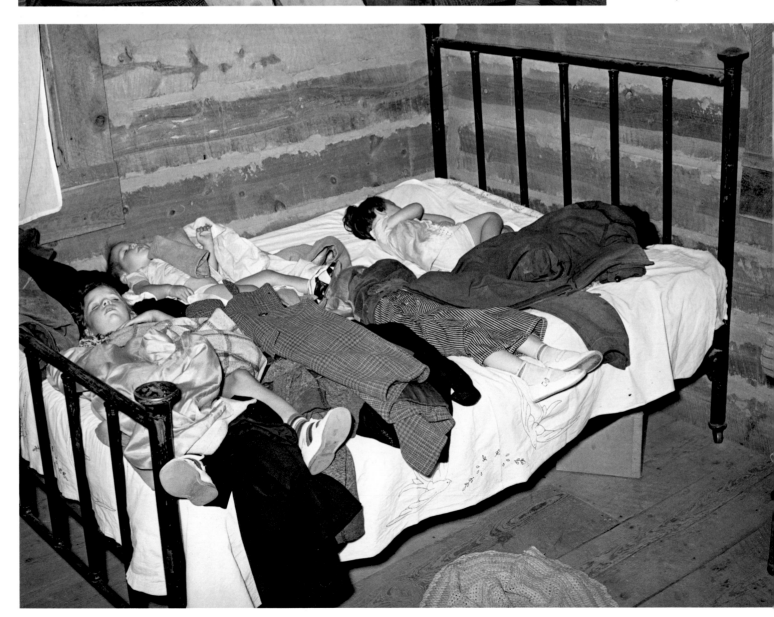

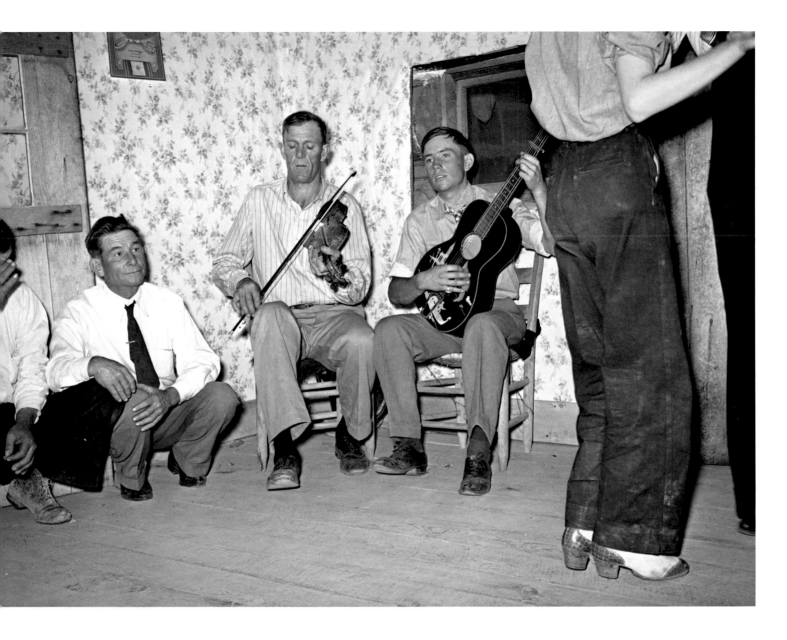

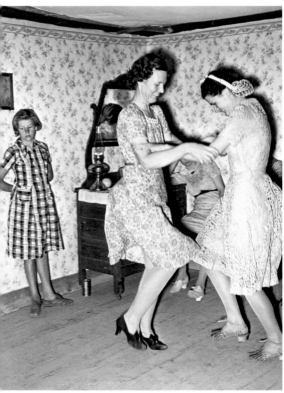

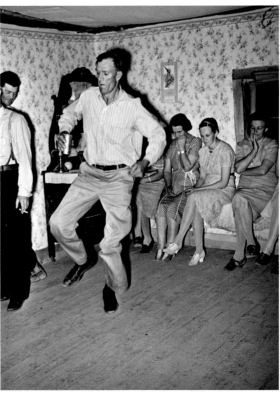

60. **Musicians at a square dance. Pie Town, June 1940**

61. **The square dance. Pie Town, June 1940**

62. **Jigger at a square dance. Pie Town, June 1940**

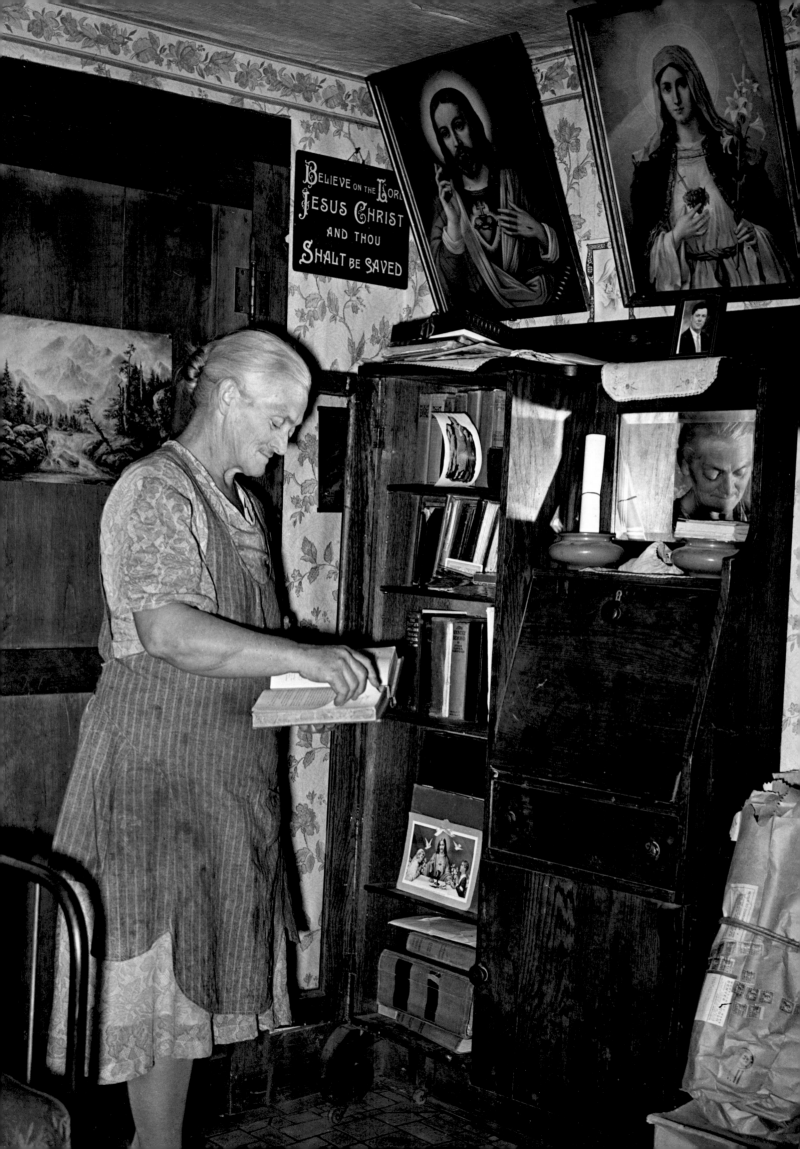

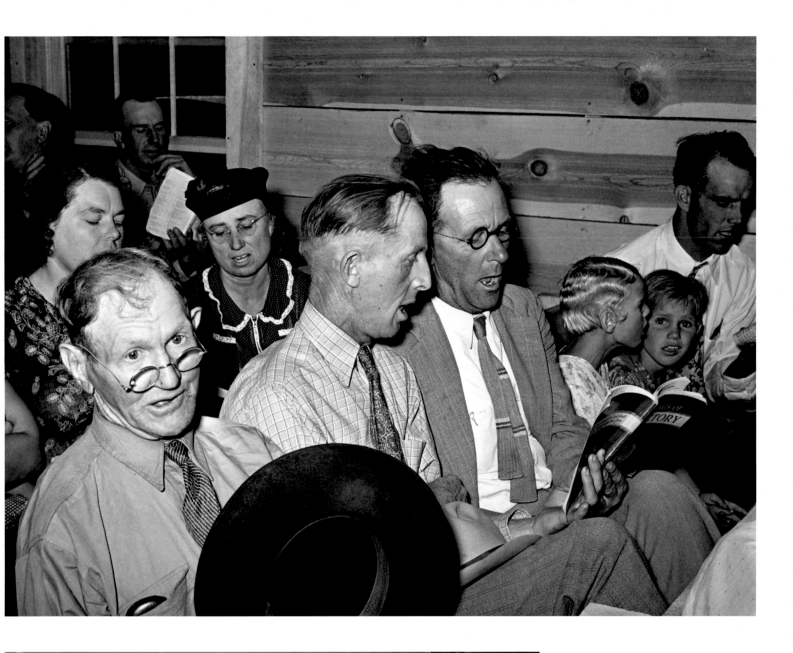

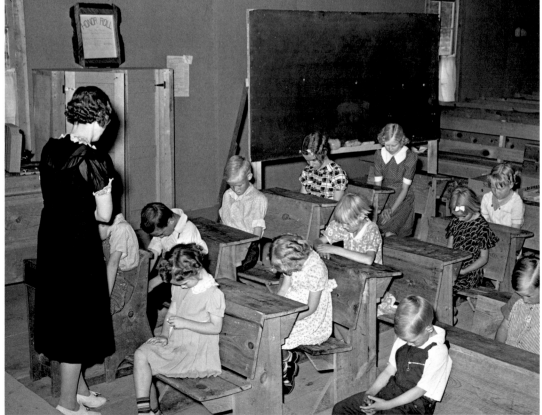

63. **Mrs. George Hutton in front of a bookcase. Pie Town, June 1940**

64. **At the community sing. Pie Town, June 1940**

65. **School opens with prayer. This is the private school in the Farm Bureau building. Pie Town, June 1940**

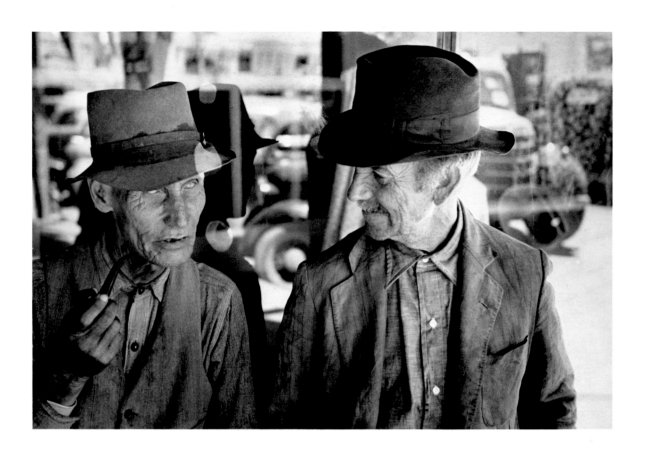

66. **Men talking on the street.**
Taos, July 1940

67. **Mr. Keele, merchant and president of the Farm Bureau, in front of the general store.**
Pie Town, June 1940

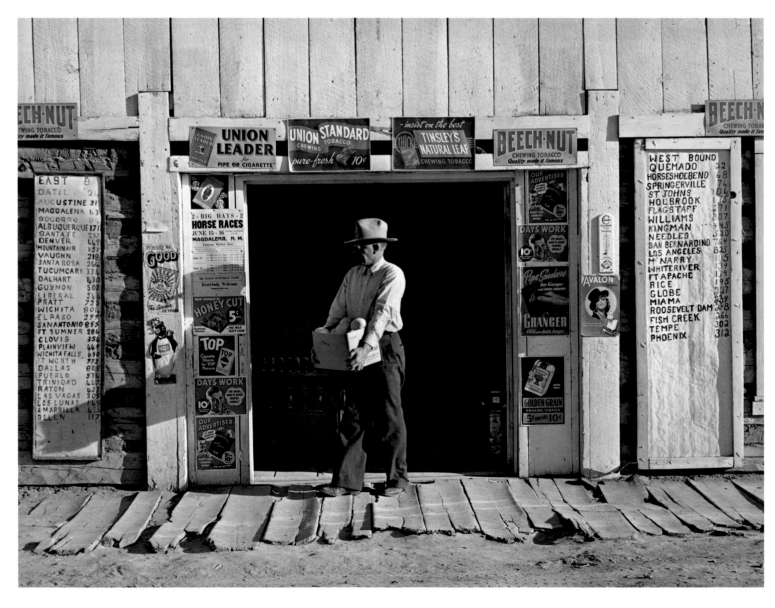

68. **Mrs. Hutton opening an electric washing machine. Her son put in all the electric equipment. Pie Town, June 1940**

69. **Mrs. Bill Stagg, home-steader's wife, putting the coffee on the table for dinner which consisted of homecured ham and gravy, pinto beans, corn, homemade pickles, home-grown tomatoes, homemade bread and hot biscuits, fruit salad, cake, two kinds of pie, milk and coffee. Pie Town, June 1940**

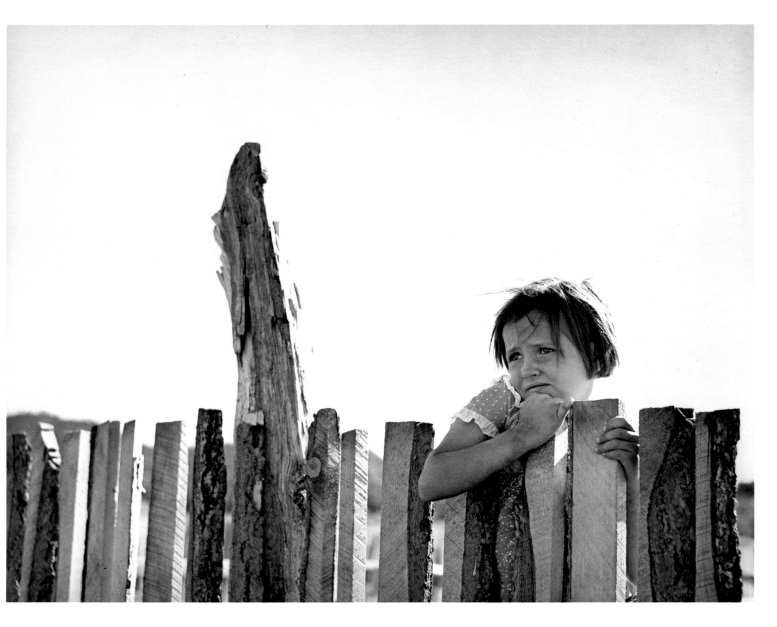

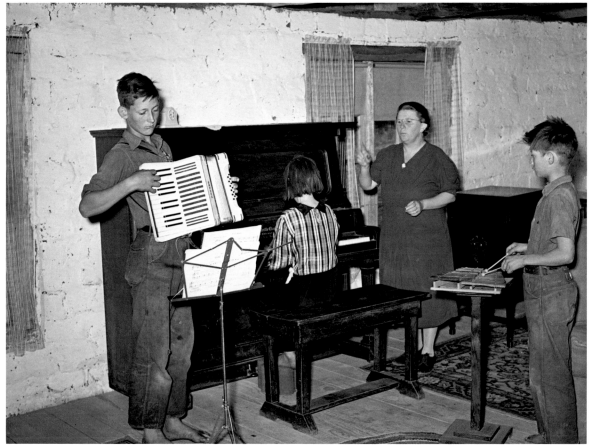

70. **Josie Caudill, homesteader's daughter, combs her hair. Pie Town, June 1940**

71. **Josie Caudill looking over slab fence on her father's farm. Pie Town, June 1940**

72. **Wife of a homesteader with her WPA music class. These children walk eight miles for their music lesson. Pie Town, June 1940**

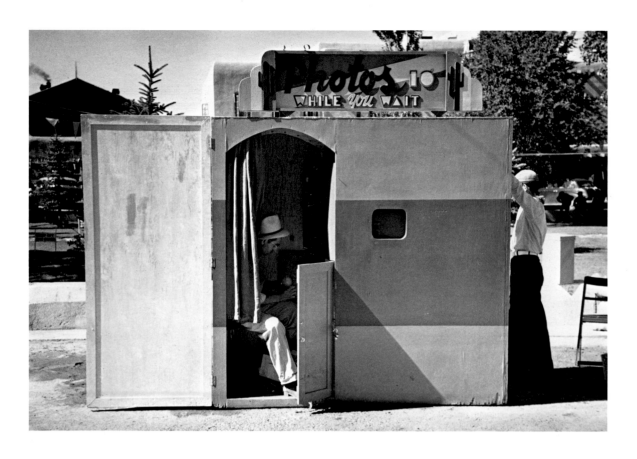

73. **Quick photographic studio at the fiesta. Taos, July 1940**

74. **Secondhand tires displayed for sale. San Marcos, Texas, March 1940**

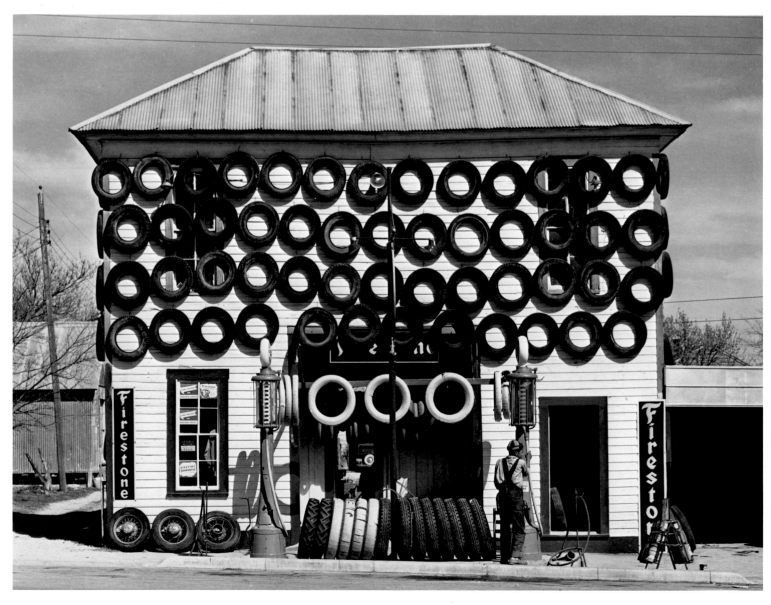

75. **Spanish-American clowns at a traveling show. Peñasco, July 1940**

76. **Clown rider with his trick mule at the rodeo. Quemado, June 1940**

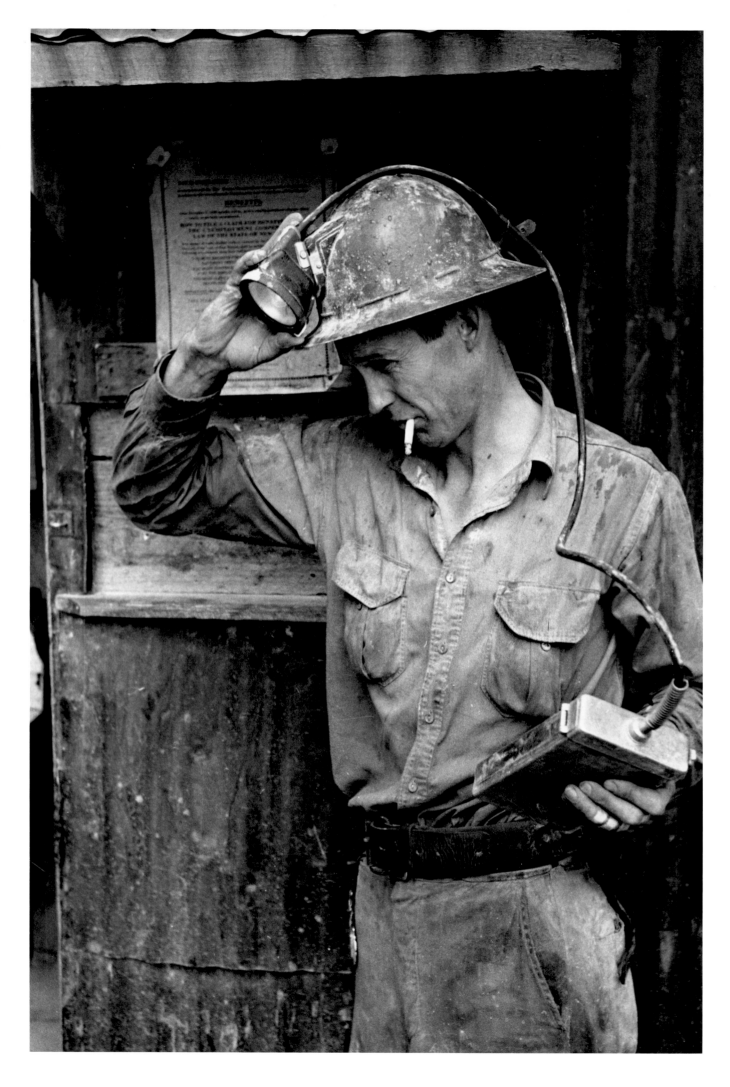

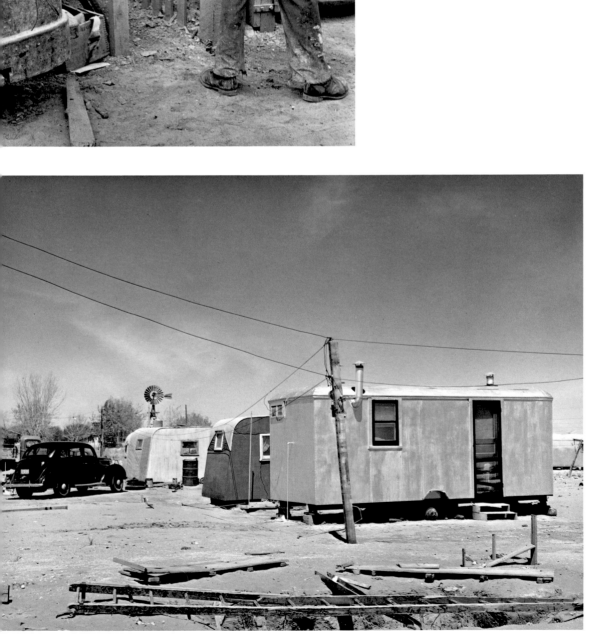

77. **Gold miner removing a light from his metal hat. Mogollon, June 1940**

49

78. **Gold miner waiting for the cage to be lowered underground. Mogollon, June 1940**

79. **Trailer homes of oil field workers. Hobbs, March 1940**

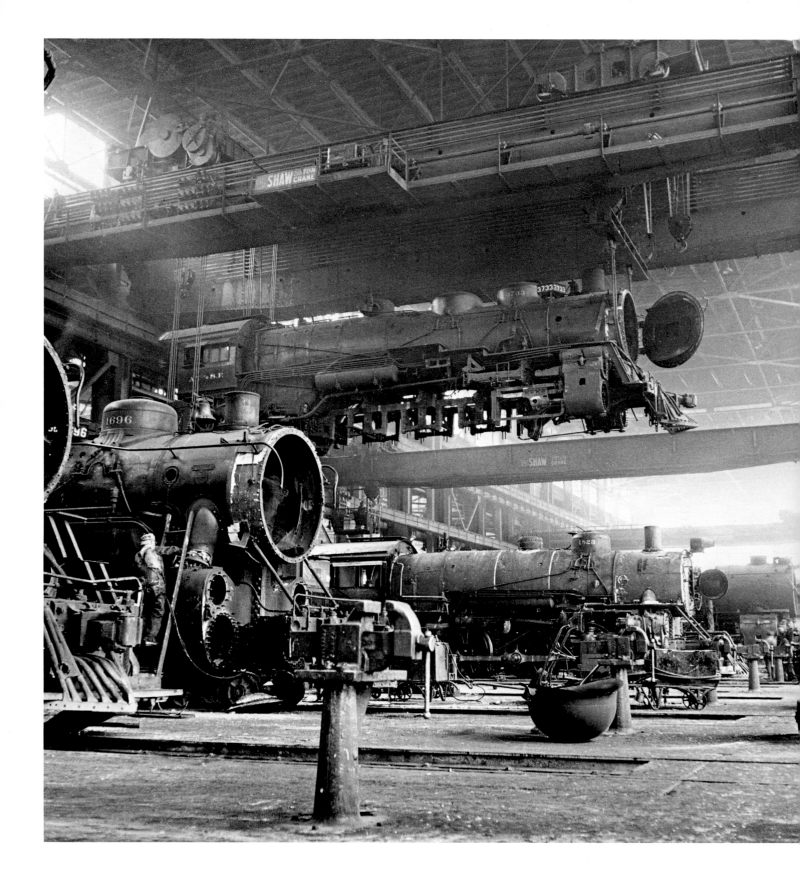

Jack Delano

80. **An engine being carried to another part of the Atchison, Topeka and Santa Fe railroad shops to be wheeled. Albuquerque, March 1943**

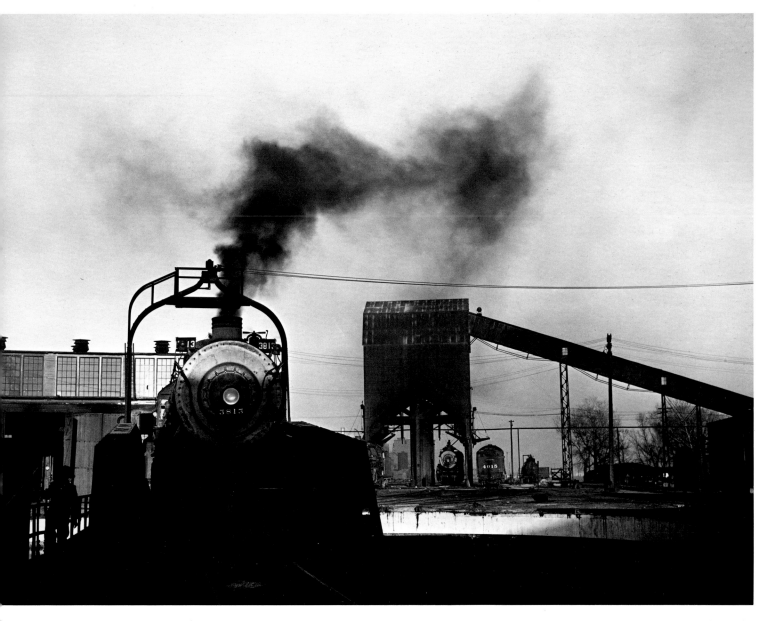

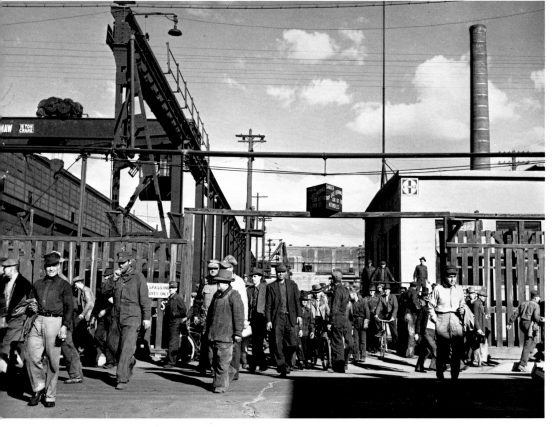

81. **Roadhouse and coal chute on the Atchison, Topeka and Santa Fe railroad. March 1943**

82. **Men coming out of the Atchison, Topeka and Santa Fe railroad between Seligman, Arizona, and Needles, California. Nelson (vicinity), Arizona, March 1943**

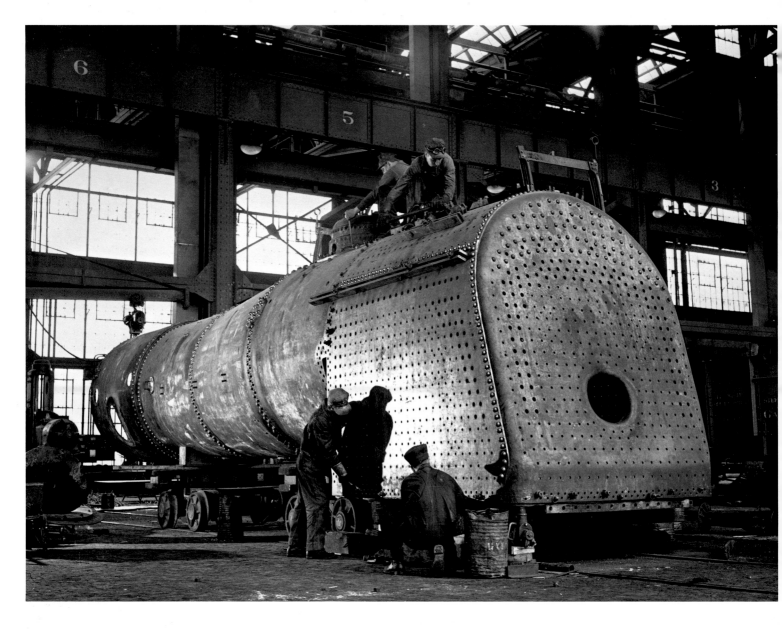

83. **Working on the firebox of an engine in the Atchison, Topeka and Santa Fe railroad locomotive shops. Albuquerque, March 1943**

84. **Hammering out a draw bar under the steam hammer at the Atchinson, Topeka and Santa Fe railroad blacksmith shop. Albuquerque, March 1943**

85. Lowering half of a locomotive housing onto roller bearings of the drive wheel axle in the Atchison, Topeka and Santa Fe railroad wheel shop. Albuquerque, March 1943

86. Part of the Atchison, Topeka and Santa Fe railroad store department. Over 35,000 items are kept on hand here. Albuquerque, March 1943

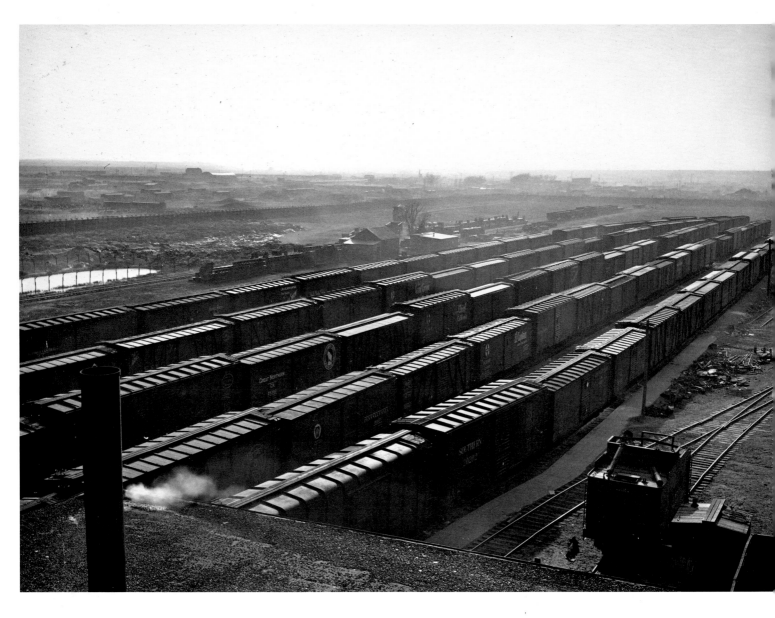

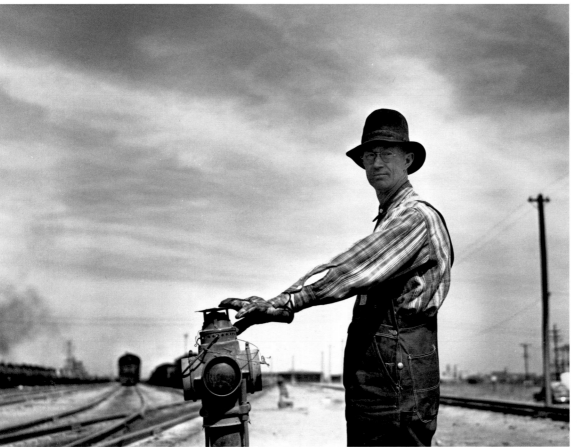

87. **Sand storm over Atchison, Topeka and Santa Fe railroad. March 1943**

88. **C. E. Bonney, switchman at the Atchison, Topeka and Santa Fe railyard. Amarillo, Texas, March 1943**

89. **Joseph Pina, boilermaker in the Atchison, Topeka and Santa Fe railroad locomotive shops for thirty-four years. Albuquerque, March 1943**

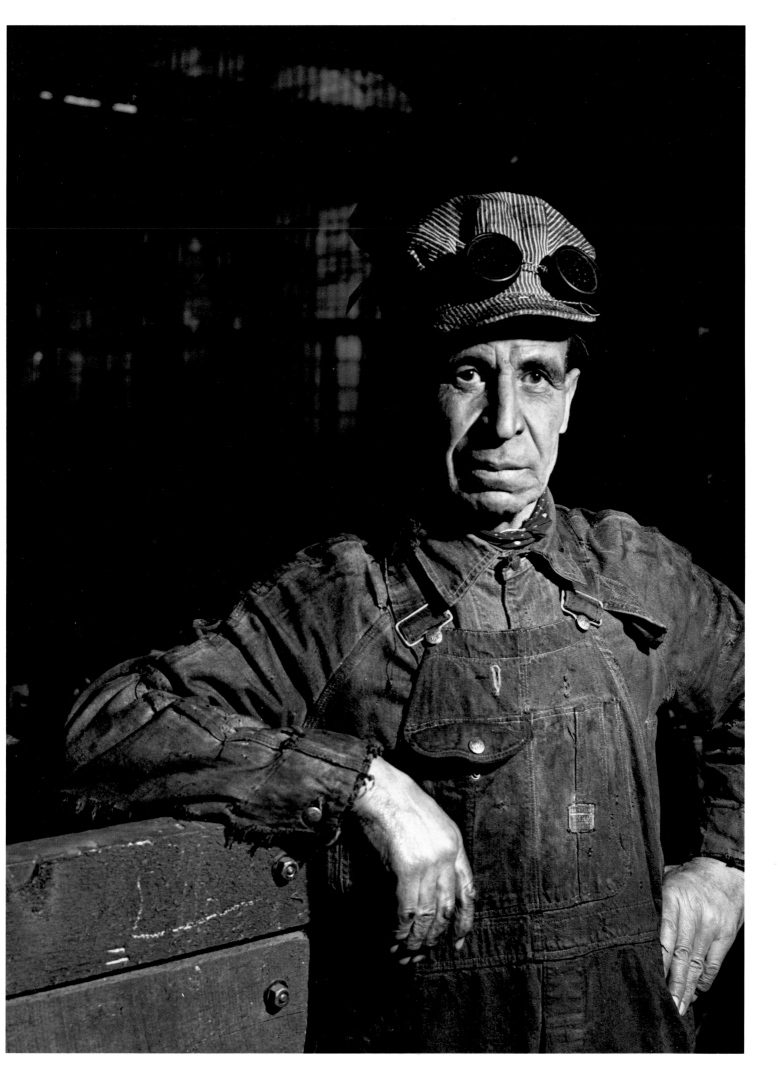

90. Conductor C. W. Tevis, picking up a message from a woman operator on the Atchison, Topeka and Santa Fe railroad between Belen and Gallup. Dalies, March 1943

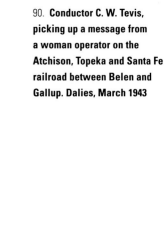

90. **Conductor C. W. Tevis, picking up a message from a woman operator on the Atchison, Topeka and Santa Fe railroad between Belen and Gallup. Dalies, March 1943**

91. **Conductor C. W. Tevis, with the Atchison, Topeka and Santa Fe railroad car shops. Thoreau, March 1943**

92. **Conductor working on his records in the caboose en route to Canadian, Texas. March 1943**

93. **A young Indian laborer working in the Atchison, Topeka and Santa Fe railroad yard. Winslow, Arizona, March 1943**

94. **Assistant foreman George Zamora, of Mountainair, New Mexico, on a section job in the Atchison, Topeka and Santa Fe railroad yard between Clovis and Vaughn. Iden, March 1943**

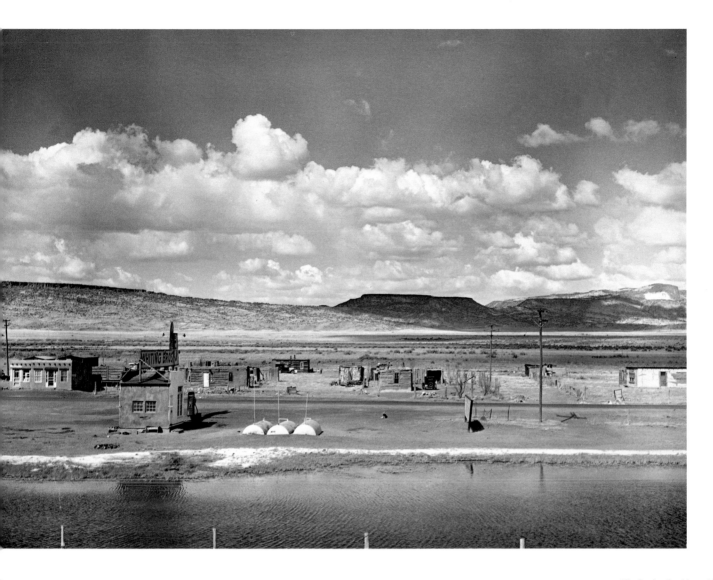

95. **On the Atchison, Topeka and Santa Fe railroad en route to Gallup. Grants, March 1943**

Have about twenty Lagunas working here. Good workers, live in village. Santa Fe [railroad] has agreement with Laguna Reservation to hire Indians preferentially in exchange for rights to get water at Laguna Reservation.

Jack Delano, April 19, 1940

96. **Flagman walks back to flag any oncoming trains while his train stops for water between Vaughn and Belen on the Atchison, Topeka and Santa Fe railroad. Willard, March 1943**

59

97. **Going across sheep and cattle country along the Atchison, Topeka and Santa Fe railroad, between Clovis and Vaughn. Duoro, March 1943**

We are heading due West and behind us the morning sun is blinding. Shiny rails go off in a straight line for the horizion. As we round a slight curve I can look out of the window and see the crazy shadows of the entire train bouncing along on the side of the tracks.

This is the kind of country I'd like to use a view camera on let alone a Rollie. Everything here is distance....

Jack Delano letter to Irene Esser Delano, March 18, 1943

98. **Atchison, Topeka and Santa Fe railroad to Clovis. Black, Texas, March 1943**

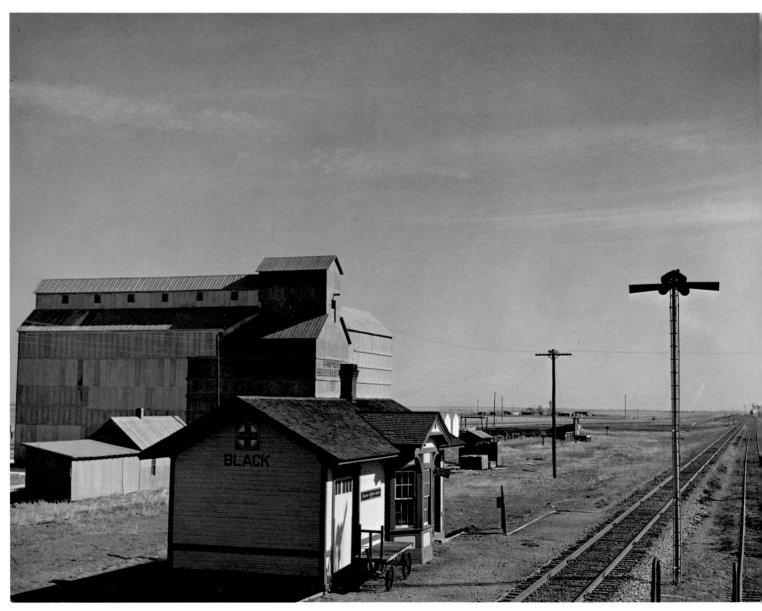

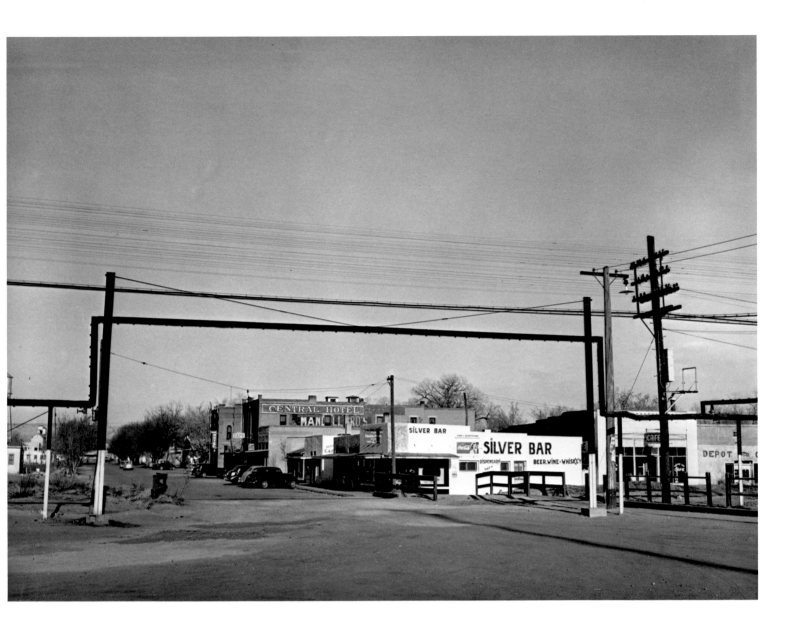

99. **Street scene near the Atchison, Topeka and Santa Fe railroad depot. Belen, March 1943**

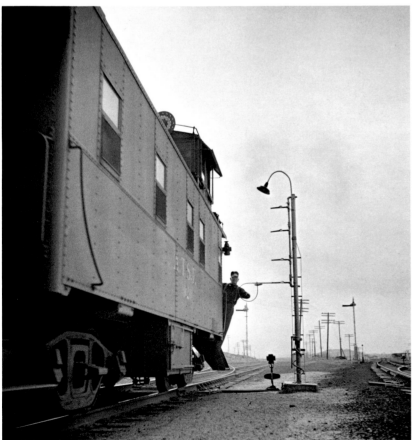

100. **Conductor of a passing freight train on the Atchison, Topeka and Santa Fe railroad picking up a message. Isleta, March 1943**

John Collier, Jr.

101. George Turner, a gunsmith as well as a cattleman, working in his shop. Moreno Valley, Colfax County, February 1943

102. A blacksmith shop. Peñasco, January 1943

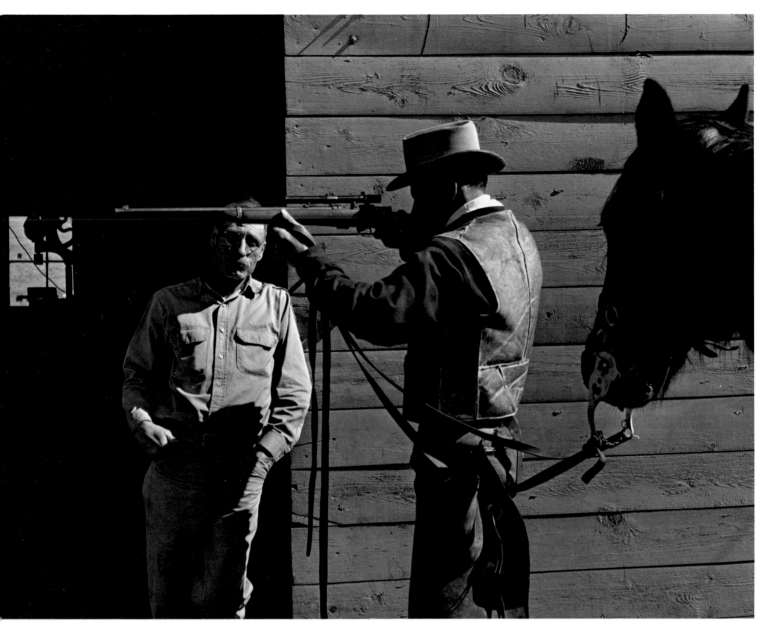

103. **John Mutz drawing a bead through a telescopic sight which George Turner has mounted on his rifle. Moreno Valley, Colfax County, February 1943**

104. **George Mutz starting out on the range in a snowstorm. Moreno Valley, Colfax County, February 1943**

63

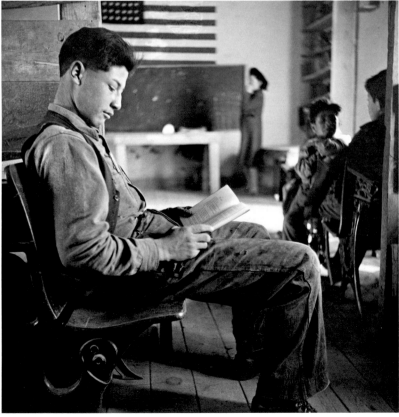

105. **The younger Mutz boy with the chemical set he bought with his summer earnings. Moreno Valley, Colfax County, February 1943**

106. **Father Cassidy, priest of the parish of Peñasco, and his Boy Scouts. Peñasco, January 1943**

107. **One-room school in an isolated mountainous Spanish-American community, which has eight grades and two teachers. Most of the teaching is in Spanish, the language spoken in the children's home, and as a result they rarely speak English fluently. Ojo Sarco, January 1943**

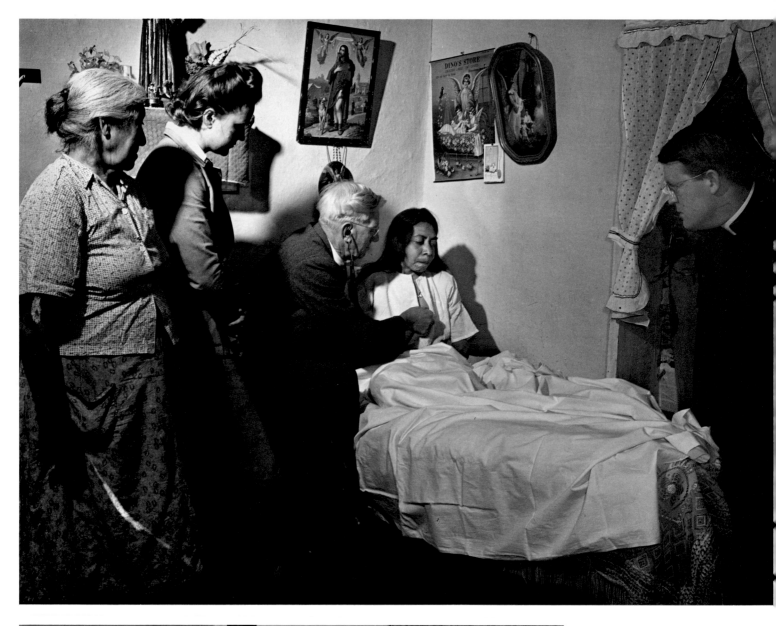

108. **Doctor Onstine, of the clinic operated by the Taos County co-operative health association, and Father Smith, the parish priest, at the bedside of a tuberculosis patient. Questa, January 1943**

109. **Marjorie Muller, nurse from the clinic operated by the Taos County co-operative health association, making a home call. Llano Quemado (vicinity), January 1943**

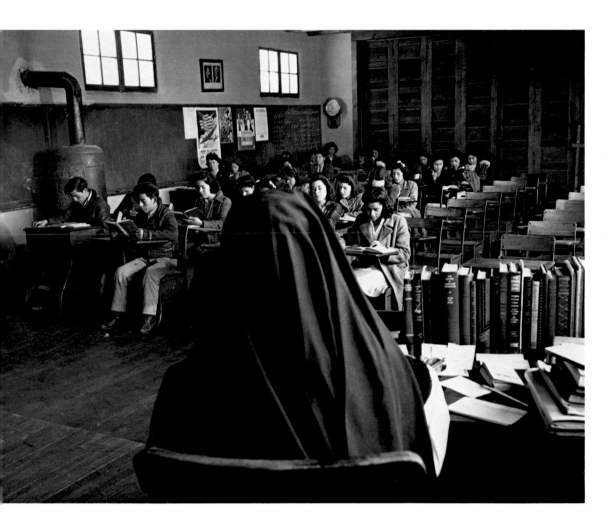

110. **High school supported by the state but administered by the Catholic church. Peñasco, January 1943**

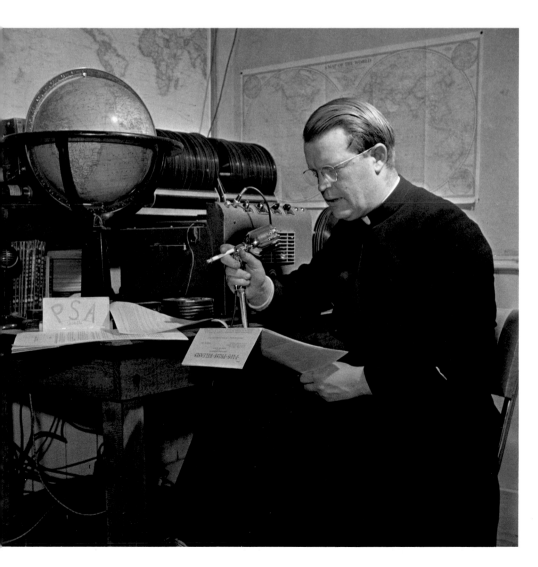

111. **Father Smith broadcasting a news release in Spanish from his parish house broadcasting**

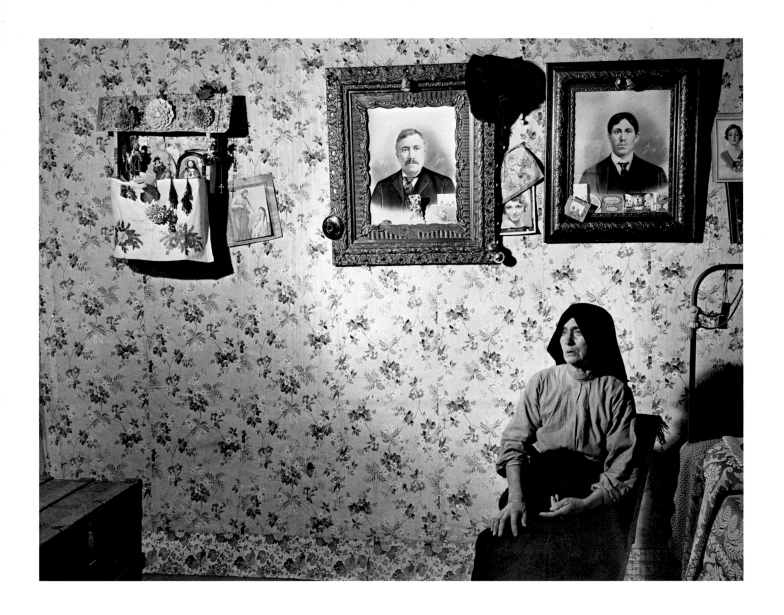

112. **Home of an old couple. Peñasco, January 1943**

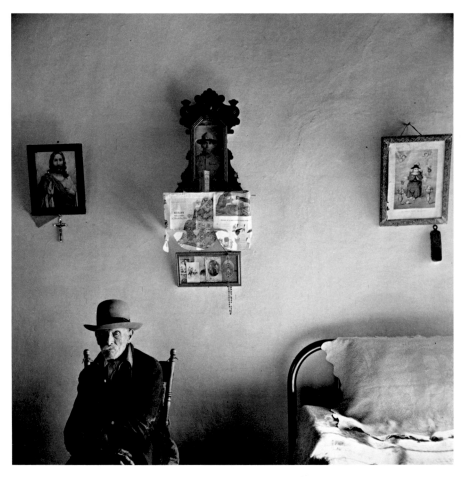

113. **Grandfather Romero, a member of the family of Juan Lopez, the majordomo, is ninety-nine years old. Trampas, January 1943**

114. **An altar in the church. The prevailing colors are grey and blue. A Coca-cola bottle is used as a candle holder. Trampas, January 1943**

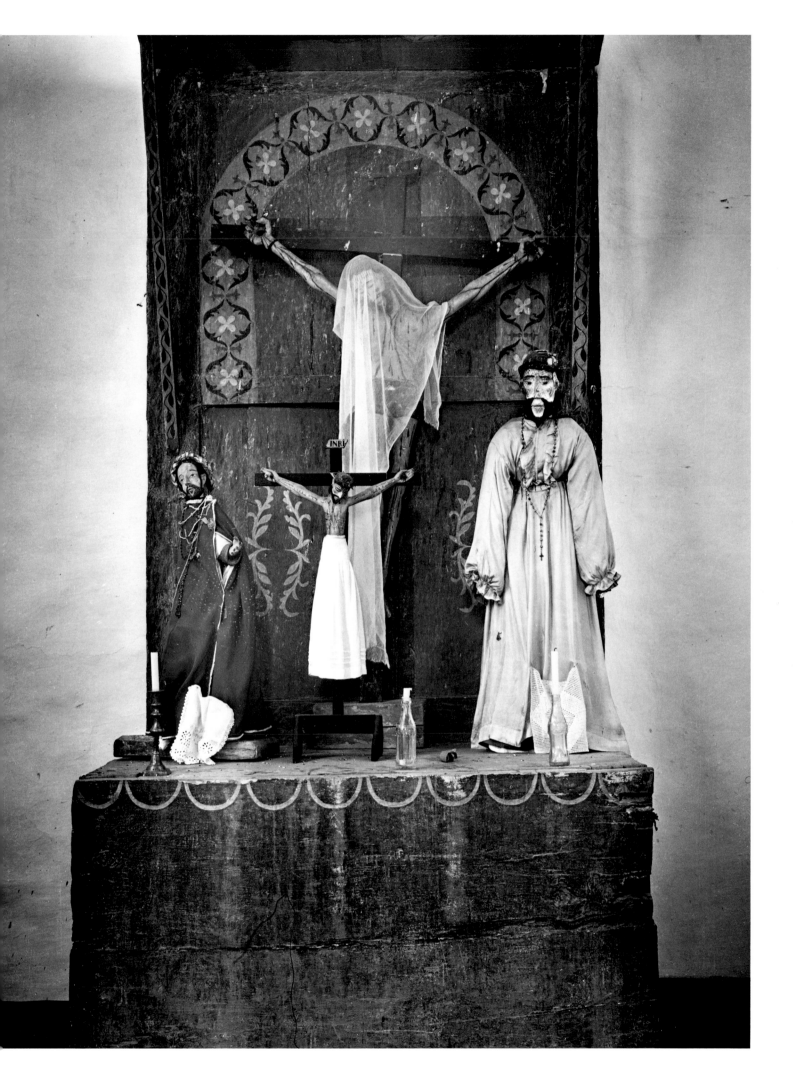

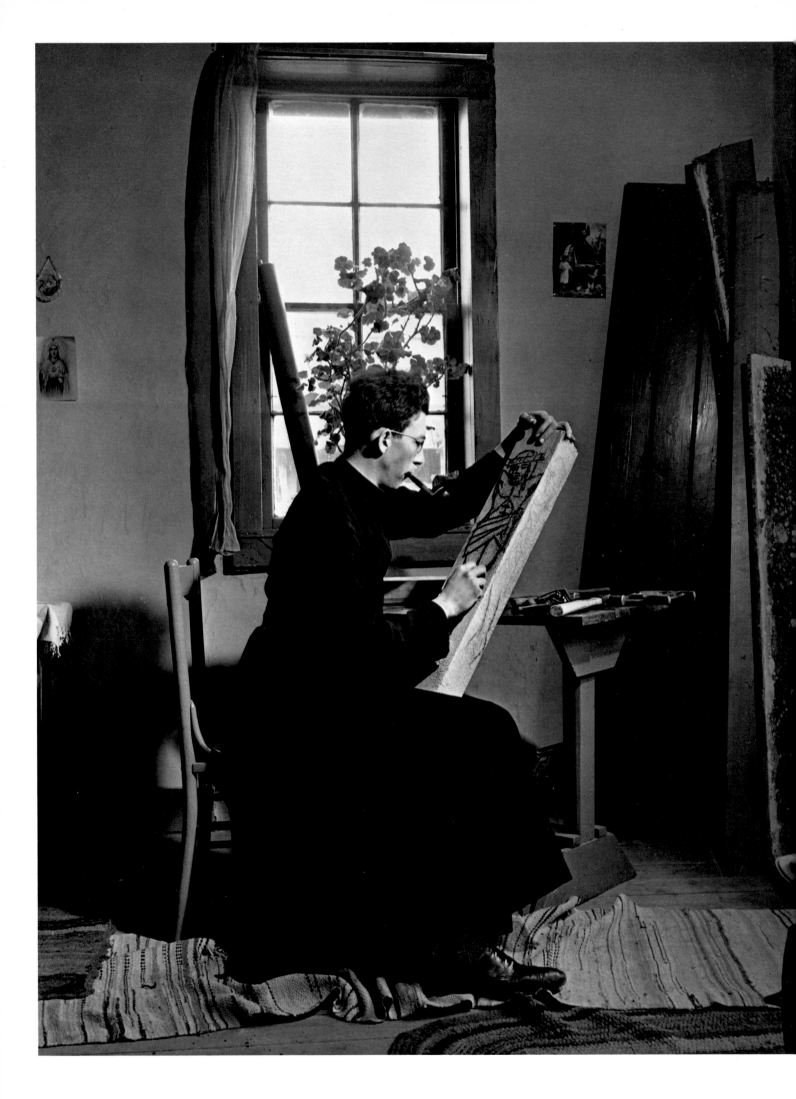

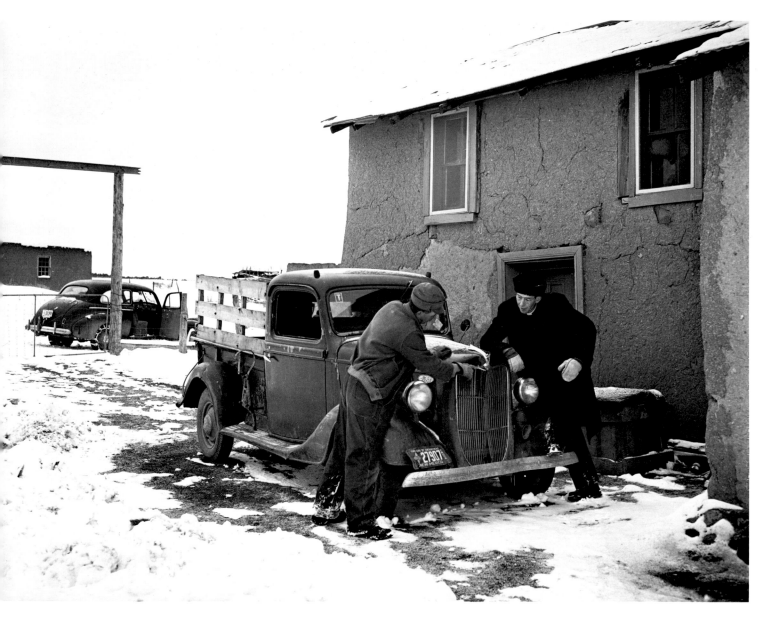

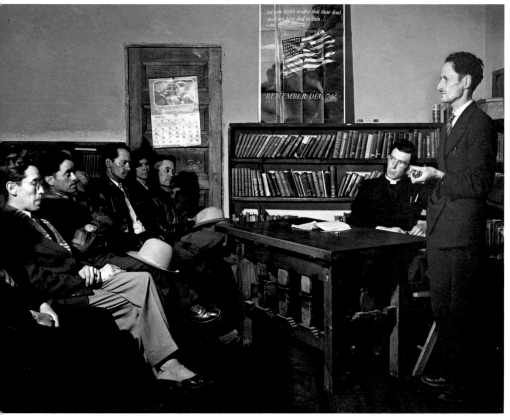

115. **Father Cassidy, the resident priest of the parish of Peñasco, wood carving. Taos county, January 1943**

116. **Father Cassidy helps fix a car. Taos County, 1943**

117. **Parent-teachers' association meeting in the High School. Peñasco, January 1943**

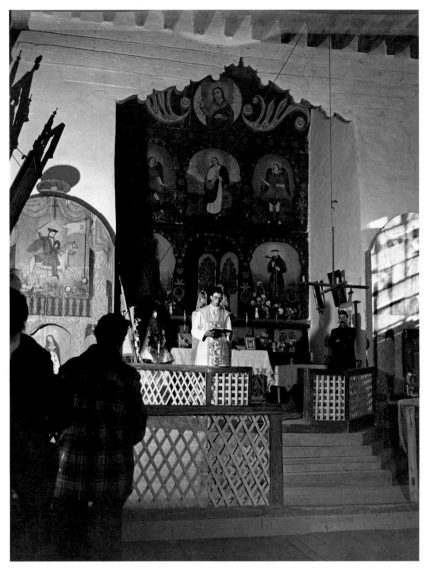

Clear freezing day – Clouds have lifted – The Sangre de Cristos are shimmering in ice and misty snow – The Ground is frozen hard as iron – crackling – brittle to the step – But it does not feel cold! the sun is blazing and fine snow lifted on the wind sparkle[s] and flame[s].

John Collier, Jr. to Roy Stryker, Taos, December 19, 1942

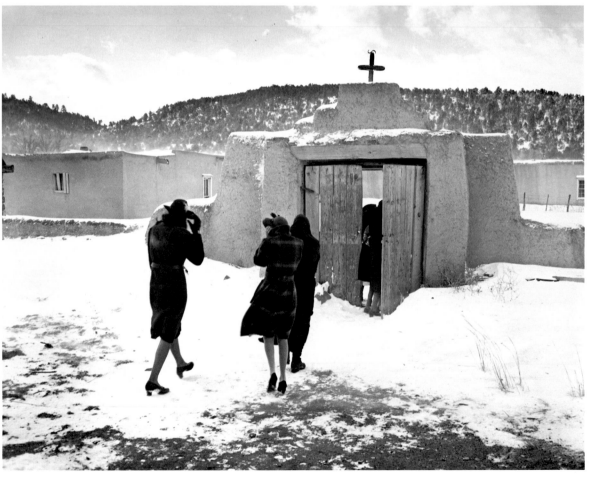

119. **Congregation leaving the church after mass. Trampas, January 1943**

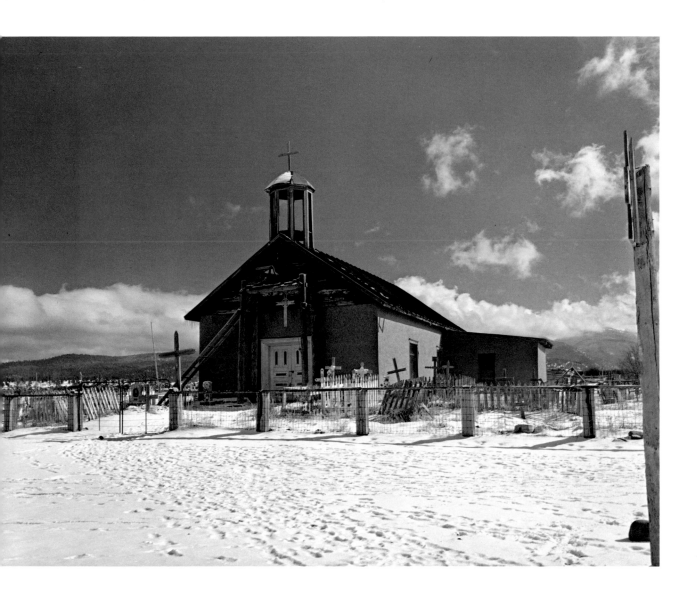

120. **Church at Llano, near Peñasco. January 1943**

121. **The graveyard behind the Penitente Morada. Llano, near Peñasco, January 1943**

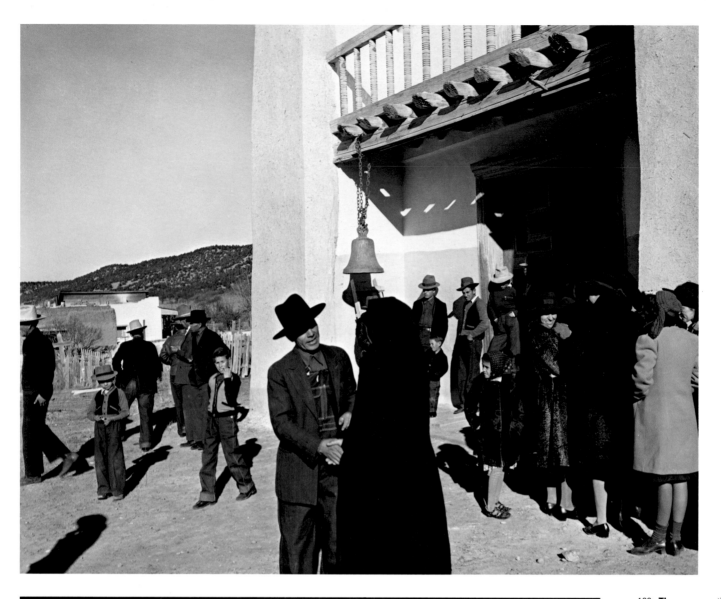

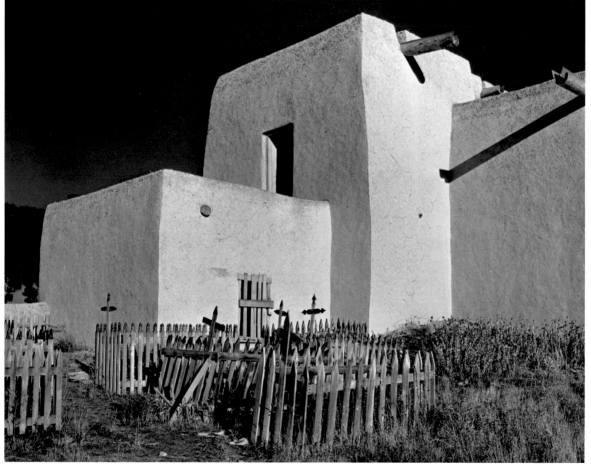

122. **The congregation leaving the church after a mass. Trampas, 1943**

123. **The graveyard outside the church. Trampas, January 1943**

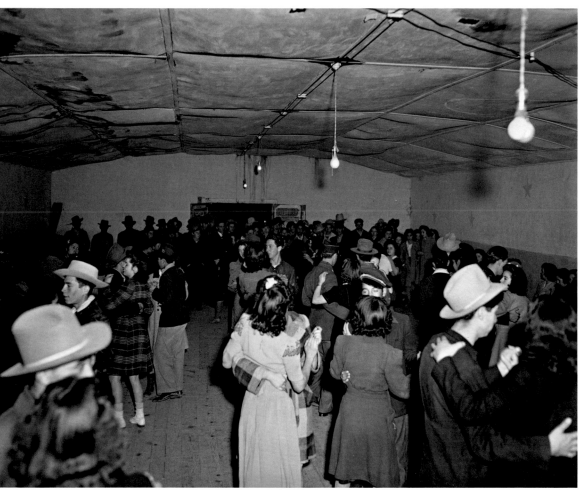

124. **A dance. Peñasco, January 1943**

125. **A native band at a dance. Peñasco, January 1943**

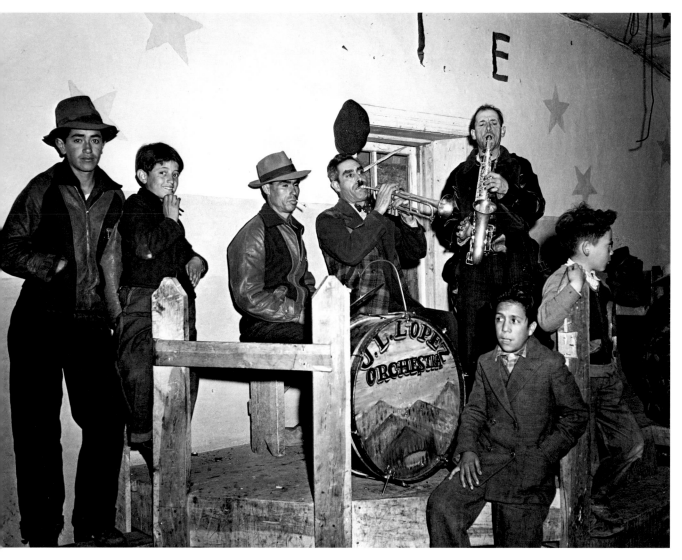

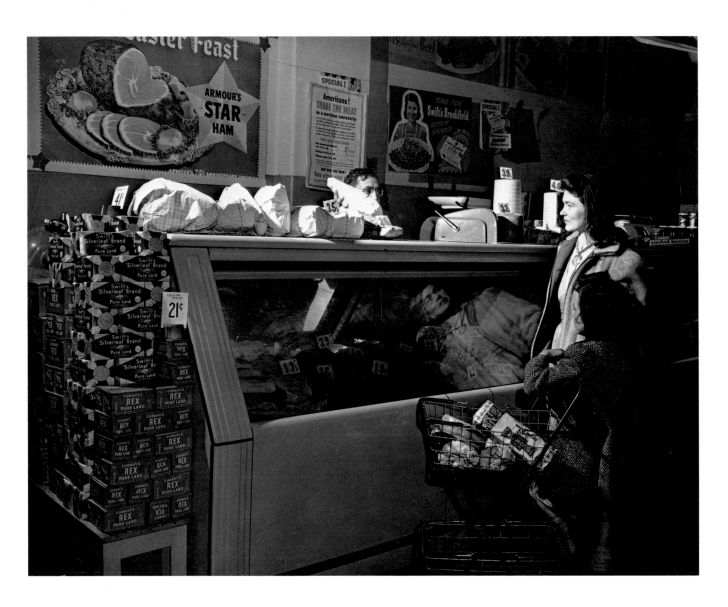

126. **First week of wartime food rationing. Taos, February 1943**

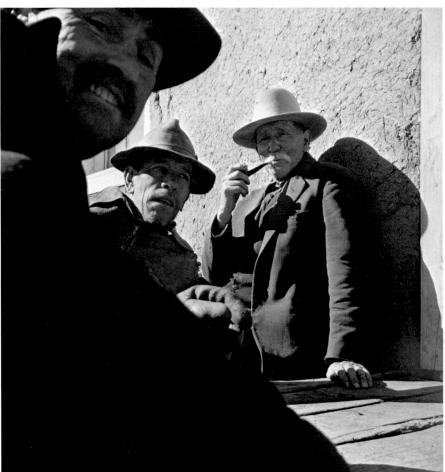

127. **Idlers at the general store. Chacon, Mora County, January 1943**

128. **Post office in the general store. Trampas, January 1943**

129. **A store. Trampas, January 1943**

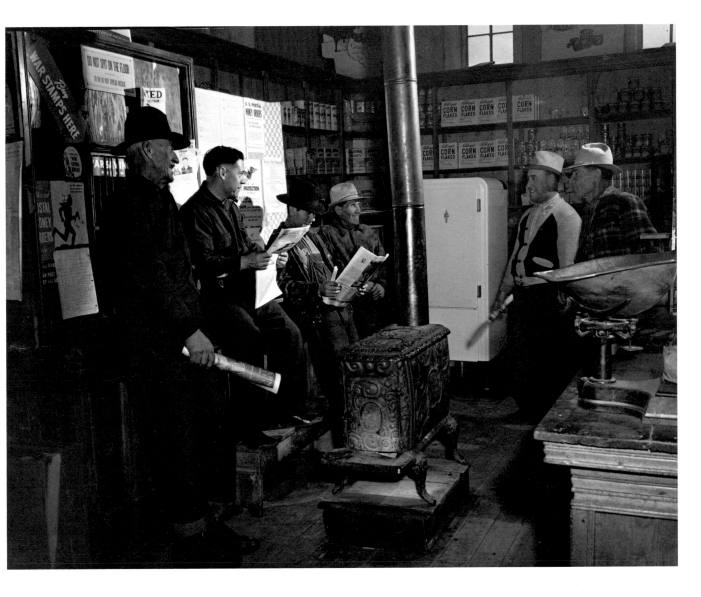

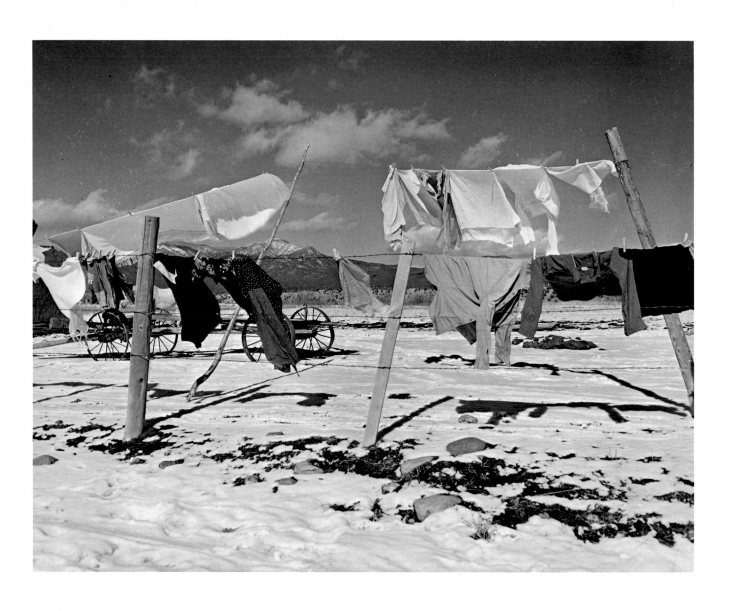

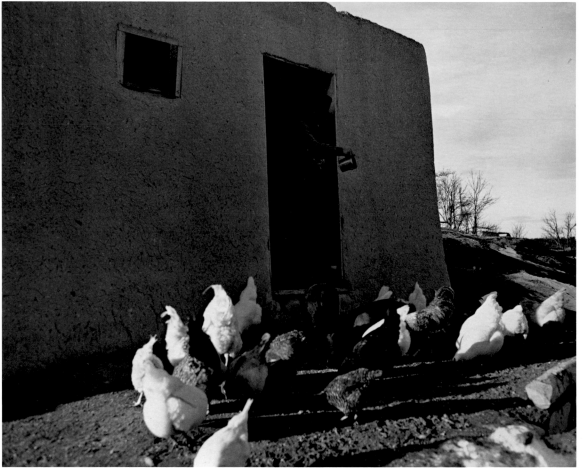

130. **Barbed wire fences make excellent clothes lines. Peñasco, January 1943**

131. **The home of Juan Lopez, the majordomo, consists of four rooms, a small orchard, a store-house and corrals where the wagon is stored and the cows and horses given shelter from the winter blizzards. Trampas, January 1943**

132. **The Penitente cross.
Truchas, January 1943**

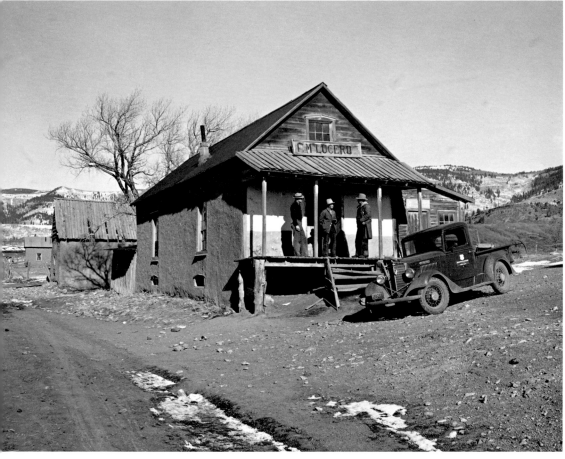

133. **A store. Chacon, Mora
County, January 1943**

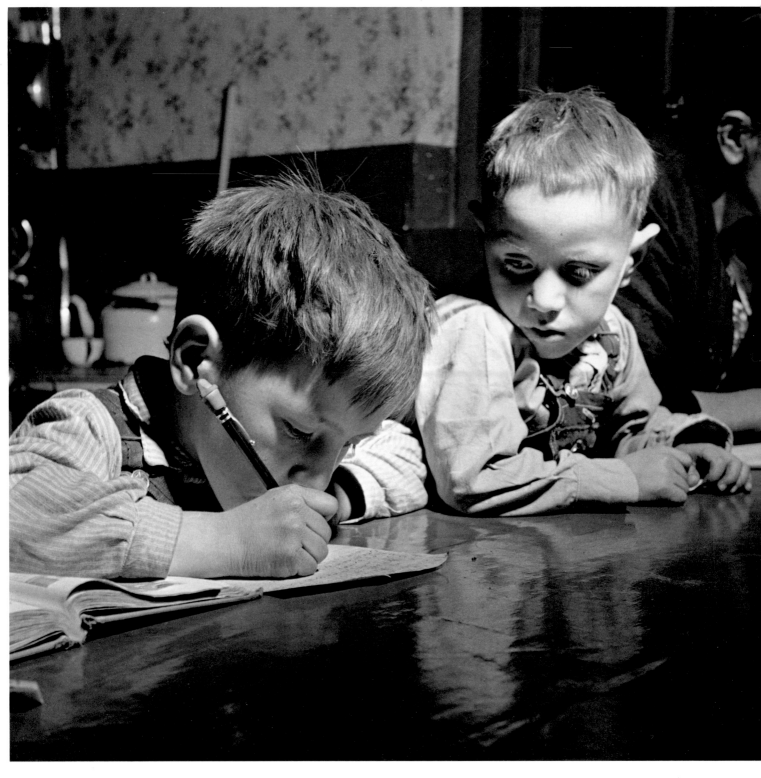

134. **The Lopez children doing their homework on the kitchen table. Trampas, January 1943**

You have no idea how far away I feel here. I fear I've slipped quite out of pace –
and become deeply involved with my own land again. This is my home, Roy.

John Collier, Jr. to Roy Stryker, Peñasco, January 13, 1943

135. **Spanish-American boy.**
Trampas, January 1943

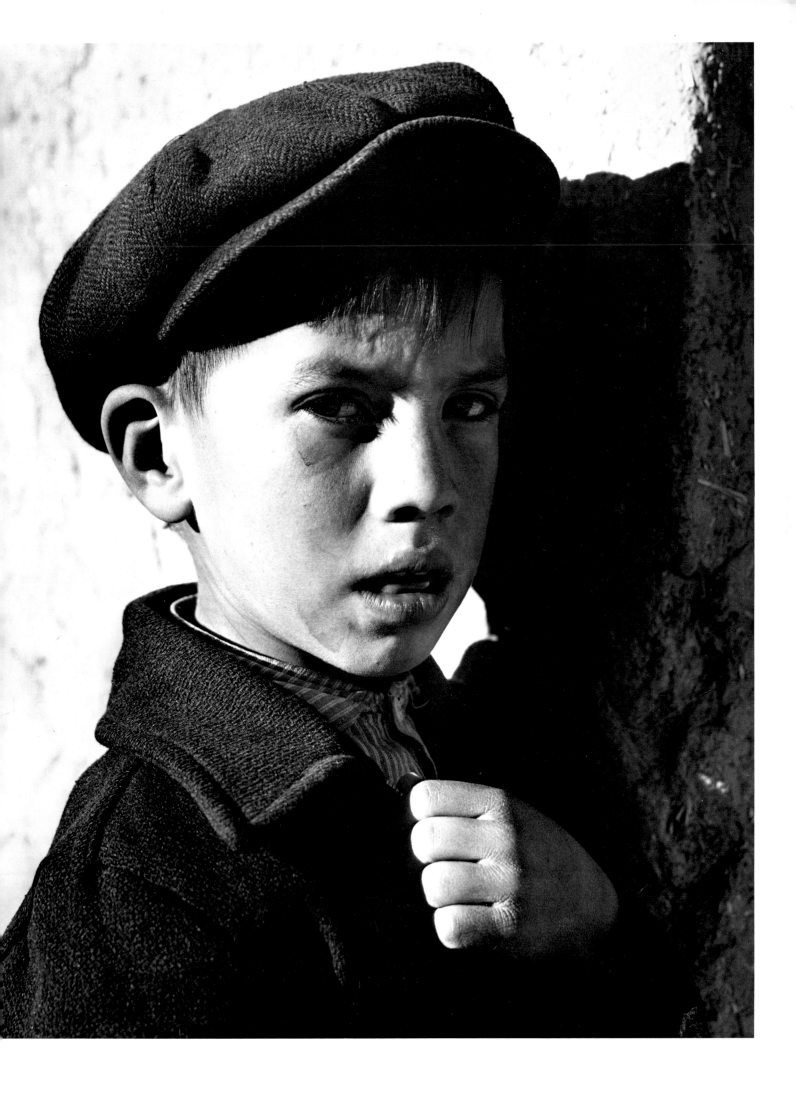

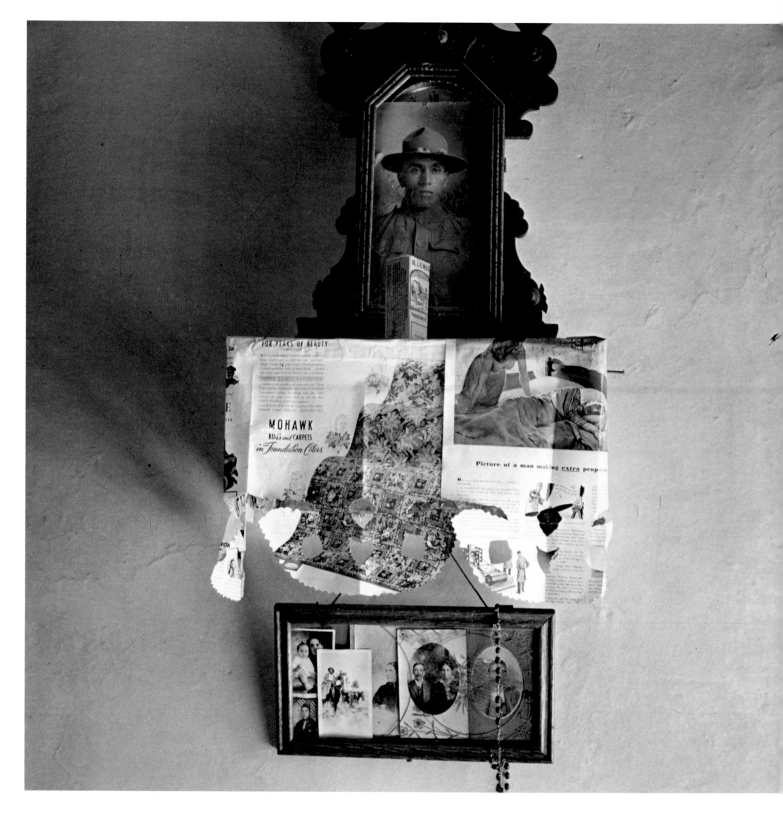

136. **Photographs on the wall of grandfather Romero's bedroom, in the house of Juan Lopez, the majordomo. Trampas, January 1943**

137. **Bulletin board in the post office. Questa, January 1943**

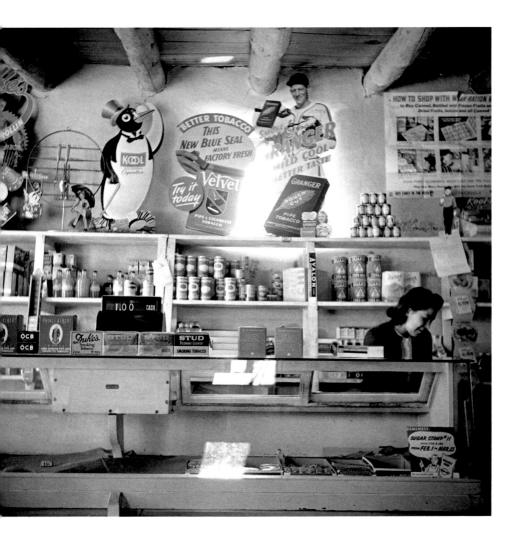

138. **The general store.**
Questa, January 1943

Afterword

Steve Yates

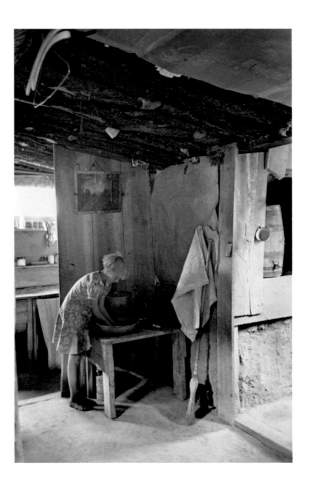

139. **Jack Whinery's daughter washing her hands. This picture was taken in the dugout with natural lighting. Notice the water cooler in the cooling room at right. This cooling room is built cellar-like into the ground. Pie Town, June 1940**
Photograph by Russell Lee

I try not to have things look as if chance had brought them together, but as if they had a necessary bond between them.

JEAN-FRANÇOIS MILLET, about 1860[1]

To know in order to do: such has been my thought. To be able to translate the customs, ideas, and appearance of my time as I see them – in a word, to create living art – this has been my aim.

GUSTAVE COURBET, 1855[2]

Although such testimony by French Realists was written nearly a century before photographers recorded the Great Depression, a kindred spirit remains between the two periods. The photographers Russell Lee, John Collier, Jr., and Jack Delano conveyed truths from the prosaic facts of life just as the artists Jean-François Millet, Gustave Courbet, Charles Jacques, Pierre Billet, Jules Bastien-Lepage and their contemporaries had done. Their work mutually reflects the universal morals hidden beneath the traits of human existence.

A unique sense of compassion endures in the art from both centuries. Artists were dedicated with social awareness to the working class of which they were a part. As keen observers of everyday experience, their discerning visual sense operated through a determined concentration upon fact. The poetry and details of life became a timeless subject. These artists celebrated the commonality of existence beyond cultural barriers or differences.

The human condition as affected by the Depression inspired United States government photographers who spent a brief time working in the American Southwest. Like the Realists, they became an inseparable part of a new social order of working classes. Everyday life was a drama of forces at work in the midst of social change. Art championed lasting human principles.

Historically, artists have garnered the enduring values of culture through personal experience and revelation.

From diverse backgrounds and art training, and through their own intuitive and artistic devices, Lee, Collier, and Delano distilled aspects of life from certain truths discovered in the field. Their art expresses with clarity the virtues of endurance tempered by basic material realities. Their photographs transcend the informational vehicle of federal assignment much as the Realists broke with existing art standards and conventional ideals the century before.

Work from both periods deepens reality through a classical resolve. Balanced, formal, simplified and objective, the subjects of these pictures are underscored by the artist's skill and craft within the medium, whether

Retour des Champs (Return from the Fields), 1860
Jules Bastien-Lepage
Etching
Private Collection

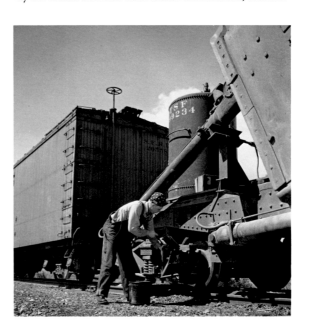

140. **Brakeman R. E. Capsey, repacking a journal box of a special car as the train waits in a siding on the Atchison, Topeka and Santa Fe railroad between Belen and Gallup, March 1943**
Photograph by Jack Delano

n etching or photograph. The resolution of content, he narrative picture structure, and the matter-of-fact immediacy and articulation of human gesture all add to this tradition of a humanized art – an art that does not rely on the limitations of the record.

Light, form, and the textures of life are added tools that help these artists animate the moment and magnify existence, but it is their individual visions which allow the particulars of life in these pictures to sustain a universal presence beyond their specific time or familiarity of the moment.

Russell Lee's instinctive picture of Jack Whinery's daughter reveals the same "necessary bond" between people and places that Millet described and Charles Jacques depicted in his rural scene. Jack Delano's portrait of brakeman R. E. Capsey, made during America's

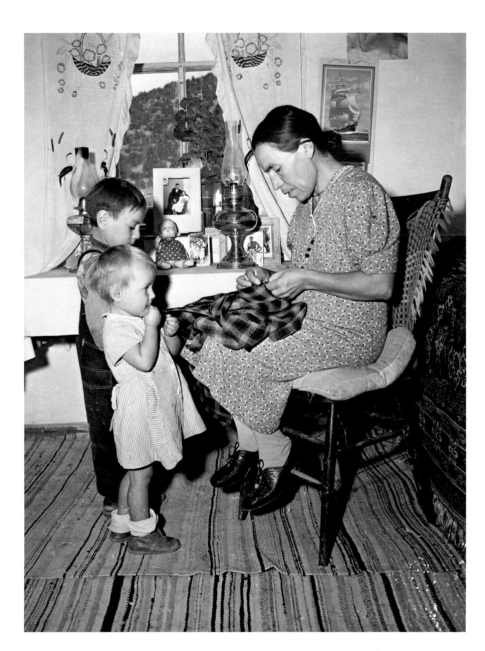

growing war effort on the railway, echoes the symbolic virtues of working women and men found in etchings by Pierre Billet or Jules Bastien-Lepage. John Collier's cinematic details of life in the Lopez family reflect the human values of upbringing not unlike Millet's image of a mother feeding her child.

How much an artist's response is a document as well as a personal means of expression cannot adequately be measured. Photography assimilates – perhaps more than any other art – a broad range of values and meanings because of its inherent directness. While Realism was at its height in France, photography was born. A century later, Lee, Collier, and Delano discovered ways to transform the intrinsic nature of realism through their own special photographic vernacular, extending a humanized artistic tradition from its nineteenth-century antecedent.

These photographs of New Mexico expand upon Courbet's dictum of knowing through seeing the "customs, ideas, and appearance" of one's time. As a chronicle of New Mexico, they embody the connection between people and essentials and contribute a "living art" that evokes universal threads of culture.

NOTES

1. Jean-François Millet, "To Théophile Thoré," ca. 1860.
2. Gustave Courbet, "Preface to the catalog of the exhibition at the Pavilion of Realism, The World's Fair, Paris, 1855," reprinted in *Artists on Art, from the xiv to the xx Century,* eds. Robert Goldwater and Marco Treves. (New York: Pantheon Books, 1945/1972), 292, 295.

141. **Maclovia Lopez, wife of Juan Lopez, the majordomo, sewing the children's clothes. Trampas, January 1943**
Photograph by John Collier, Jr.

(left)
Gruel, 1861
Jean-François Millet
Etching
Private Collection

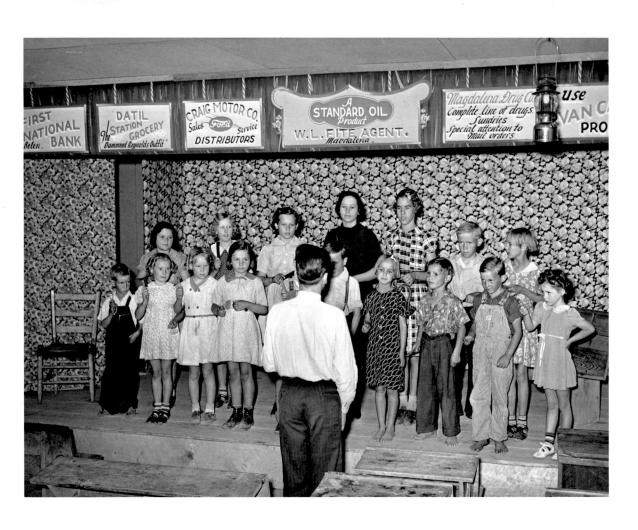

142. **Children at the private school held at the Farm Bureau building, keeping time to a phonograph with homemade musical instruments. Pie Town, June 1940**
Photograph by Russell Lee

143. **Maclovia Lopez, the wife of the majordomo, spinning wool by the light of the fire. The family has ten sheep and they spin the wool for blankets, which are woven for them in Cordova. Trampas, January 1943**
Photograph by John Collier, Jr.

144. **Passing the Southern Pacific railroad station along the Atchison, Topeka and Santa Fe railroad. Vaughn, March 1943**
Photograph by Jack Delano

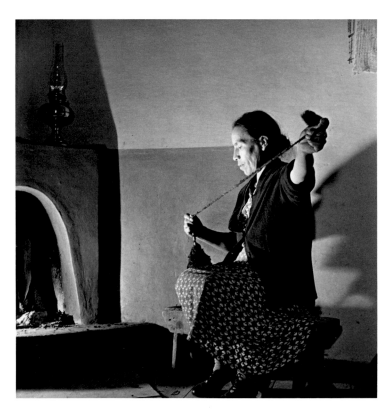

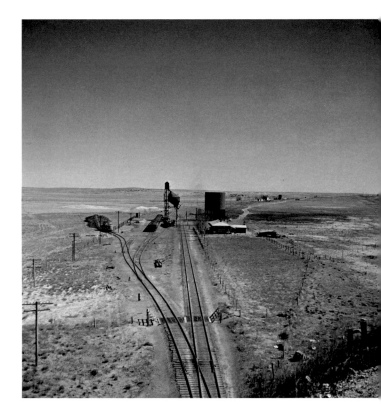